WATERCOLOR
TEXTURES
FOR ARTISTS

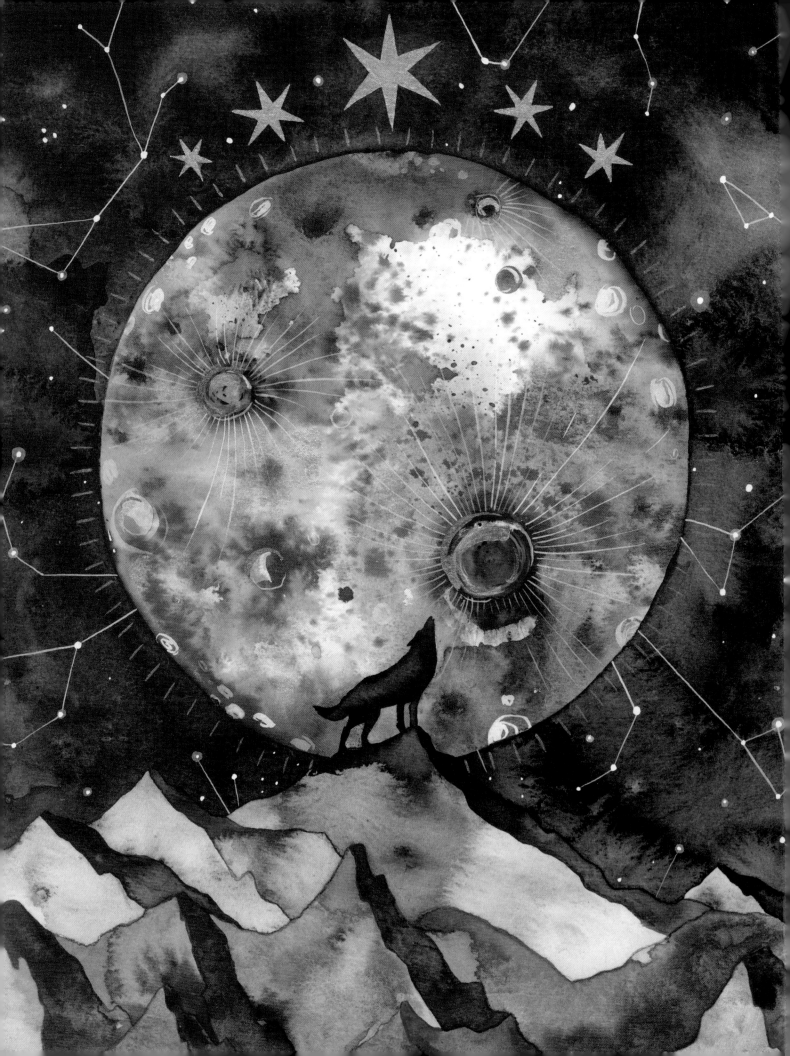

WATERCOLOR TEXTURES FOR ARTISTS

EXPLORE SIMPLE TECHNIQUES TO CREATE AMAZING WORKS OF ART

ANA VICTORIA CALDERÓN

Quarto.com

© 2024 Quarto Publishing Group USA Inc.
Text and illustrations © 2024 Ana Victoria Calderón Illustration LLC

First Published in 2024 by Quarry Books, an imprint of The Quarto Group,
100 Cummings Center, Suite 265-D, Beverly, MA 01915, USA.
T (978) 282-9590 F (978) 283-2742

Quarry Books titles are also available at discount for retail, wholesale, promotional, and bulk purchase.
For details, contact the Special Sales Manager by email at specialsales@quarto.com or by mail at
The Quarto Group, Attn: Special Sales Manager, 100 Cummings Center, Suite 265-D, Beverly, MA 01915, USA.

10 9 8 7 6 5 4 3 2 1

ISBN: 978-0-7603-8340-7

Digital edition published in 2024
eISBN: 978-0-7603-8341-4

Library of Congress Cataloging-in-Publication Data is available.

Page Layout: Megan Jones Design
Photography: Milburga Rodriguez Rivera, except Shutterstock on pages 56 (all), 58 (top), 59 (top), 60 (top),
61 (top), 62 (top), 63 (top), 64 (top), 65 (top), 66 (top), 67 (top), 69 (top), 69 (top), 70 (top), 71 (top), 72 (top),
73 (top), 74 (top), 75 (top), 76 (top), 77 (top), and 78 (top)
Illustration: Ana Victoria Calderón

Printed in China

TO MY MAGICAL

SABRINA

CONTENTS

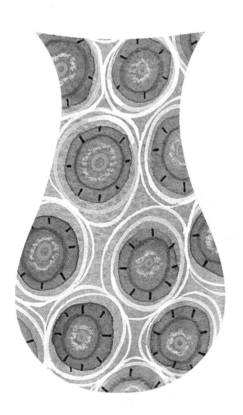
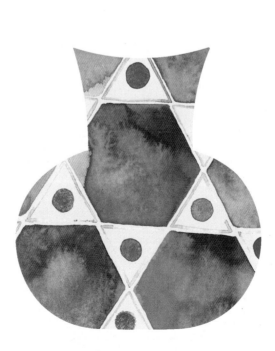
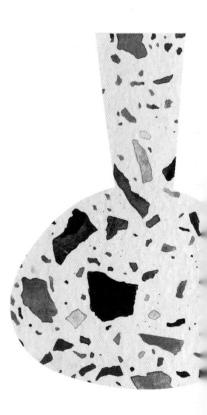

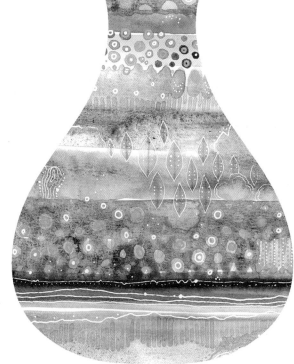

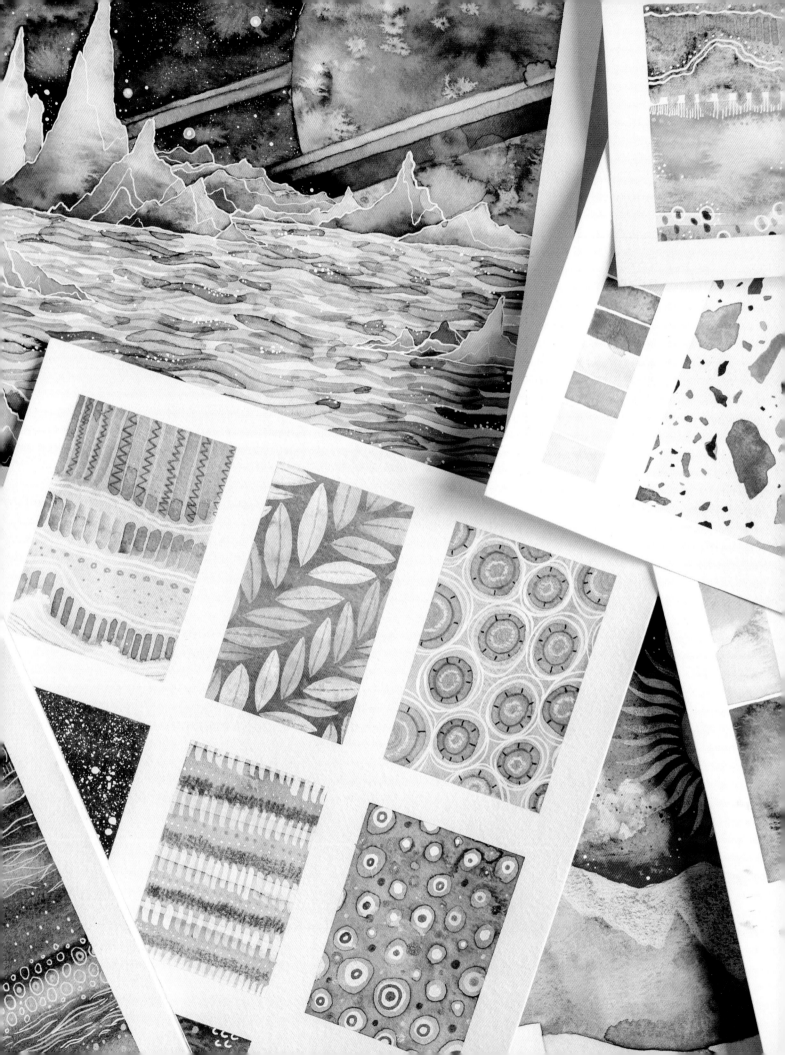

INTRODUCTION

I like to think of art as a form of intuitive practice, in which the creative process flows naturally from within. From my experience as a teacher, I find that students often feel more at ease and in the moment when they are immersed in painting. Painting with watercolors is particularly effective at cultivating this sense of relaxation and mindfulness. By connecting deeply with the world around you and observing its nuances, you can awaken your senses in a gentle yet profound way.

Art, like many aspects of life, carries a duality. On one hand, we have this beautiful inner experience of creative flow occurring, and on the other, we learn technical skills to refine the visual quality of our work. We can utilize the practical elements of painting as tools to express our feelings and tap into our creativity. As a result, it is important for artists to cultivate both aspects to create meaningful works of art. The elements of art help us express ourselves and communicate with others. Art has seven main elements:

1. **Line**: a continuous mark made on a surface

2. **Shape**: an enclosed area defined by lines or other elements

3. **Form**: a three-dimensional object or the illusion of three-dimensionality created by the use of light and shadow

4. **Space**: the area around, within, or between elements

5. **Value**: the range of lightness or darkness

6. **Color**: the hue, saturation, and brightness of an object

7. **Texture**: the tactile quality of a surface or the illusion of such a quality

These elements are the foundation of any artistic creation; the artist's distinct combination of elements will produce unique visual effects to express concepts as well as emotions.

In this book, we explore texture at a deeper level, specifically when used in watercolor paintings. Visual texture can provide context or depth to a plain surface, allowing an artist to transform a seemingly flat shape into all sorts of objects. For example, by incorporating simple lines or dots, an unassuming oval can take on the appearance of a pebble or an egg, adding an extra layer of dimensionality and meaning to the artwork.

The J. Paul Getty Museum describes texture on its website, www.getty.edu/museum, as "the surface quality of an object that we sense through touch. All objects have a physical texture. Artists can also convey texture visually in two dimensions. In a two-dimensional work of art, texture gives a visual sense of how an object depicted would feel in real life if touched: hard, soft, rough, smooth, hairy, leathery, sharp, and so on. In three-dimensional works, artists use actual texture to add a tactile quality to the work."

Although fine art often refers to texture in a literal sense—something that you are almost ready to touch by looking at the artwork or, in other words, the way an object feels— this book expands the definition of texture to include a wider range of visual effects. Rather than focusing solely on hyperrealistic or realistic art, this book embraces a playful approach to illustrative watercolor designs. Through experimentation and exploration, you can create a variety of textures, from organic lines over a brown wash to imitate the appearance of wood to repeating patterns over colorful circles for an electric and abstract piece. By broadening your understanding of texture, you can unlock new creative possibilities and expand your artistic horizons.

Textures can be conveyed as tiny dots, brick patterns, wavy lines, geometric shapes, textile patterns, splatter, fish scales, concentric circles, tie-dye, flowy marble designs, or zigzag stripes. Let your curiosity guide you as you experiment with a multitude of textures and patterns while exploring different ways to apply this element to simple drawings for stunning results.

As we explore the world of painting textures, I encourage you to approach the process with patience and ease. By repeating strokes and shapes, you will transform simple marks into intricate and beautiful designs that carry meaning and intention. With practice, you'll discover the meditative quality of this process, allowing you to lose yourself in the act of creation for a fully immersive artistic experience.

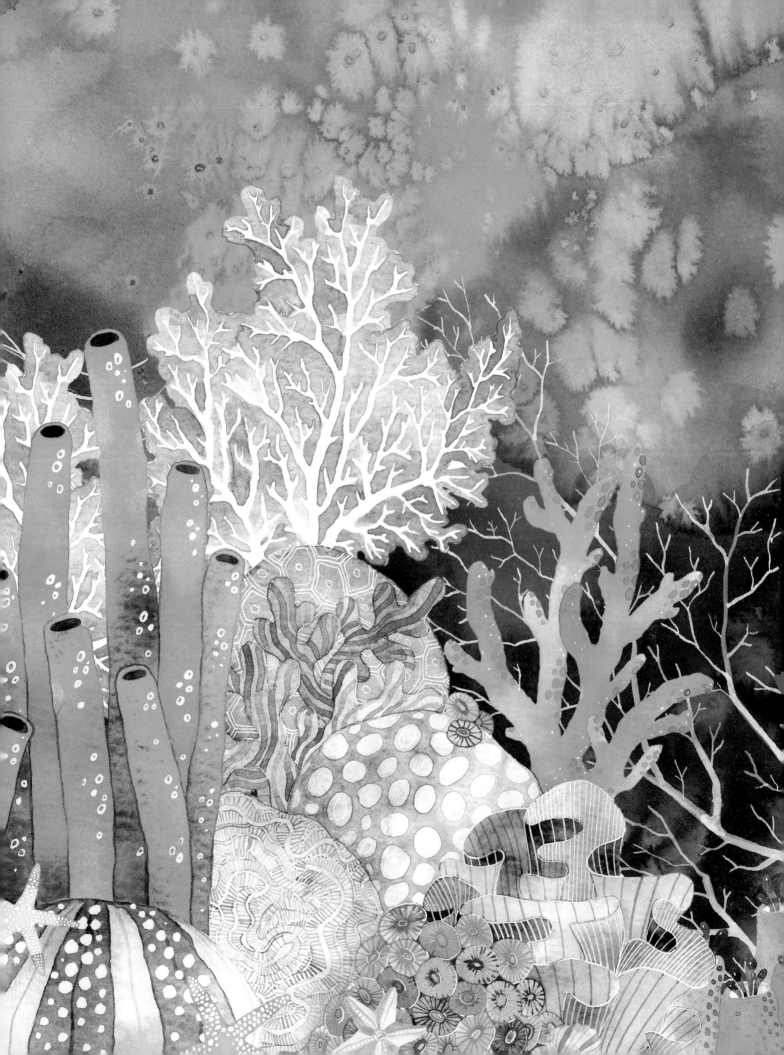

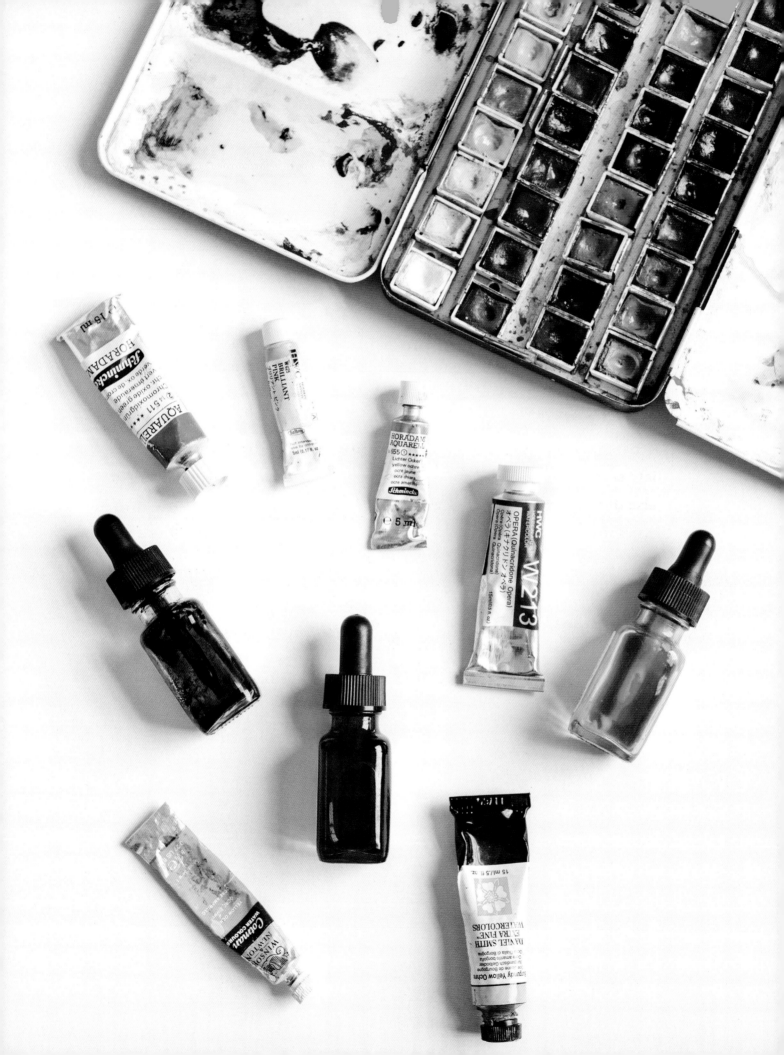

WATERCOLOR BASICS

Watercolor is an exceptional master medium. It is the most immediate form of painting because the pigment is reacting directly to the paper, which is a result of limited ingredients in the paint formula. As the paint dries, you will see the wash transform into its ultimate form, colors flowing into each other and creating beautiful blooms and gradients. You must also think strategically to avoid colors bleeding into each other when this is not the planned design. Watercolor's wet nature requires some precision but can also often lead to happy accidents.

WATERCOLOR ESSENTIALS

There is a delicate balance between making calculated decisions and letting go of an exact desired outcome, which makes watercolor painting both relaxing and stimulating.

Watercolors are easy to set up, they don't require any special solvents, and they are relatively mess-free. This portability and the numerous ways to use watercolor are two reasons that make the medium so widely loved.

If you are new to watercolors, here are a few basic techniques to take into consideration.

WATERCOLOR WASH

A watercolor wash refers to a layer of color that is somewhat transparent and covers a significant area. There are four main types of washes:

- **Flat wash.** A single color that is diluted with water and lays evenly over the paper with no visible brushstrokes. (A)

- **Variegated wash.** One color that seamlessly blends into another color. (B)

- **Graduated or gradient wash.** One color that varies in value, from dark to light or light to dark. The color fades between opaque and transparent. (C)

- **Wet-on-wet.** One color or more that is applied to a wet surface. Colors are allowed to blend fluidly. (D)

A

B

C

D

TRANSPARENCIES

Watercolor is famous for being a transparent medium. This means the ingredients in watercolor paints are not opaque enough to cover your surface completely. The white of the paper is considered the lightest value in watercolor. The more water you use, the lighter your color will be. The less water and more pigment you use, the darker your color will be.

When teaching new students how to use watercolor, explaining the difference between making pink with acrylics versus watercolor seems to be very helpful. If we are mixing pink with acrylics, we would add white paint to a small amount of red or magenta paint until we achieve the desired tone. A soft pastel pink will have about 90 percent acrylic white paint and just a touch of red or magenta acrylic paint. When using watercolors, we don't traditionally add white paint. Instead, we water down our pigment, making it quite light. The small amount of watered-down red or magenta watercolor paint over the white of the paper coming through will achieve a pastel pink.

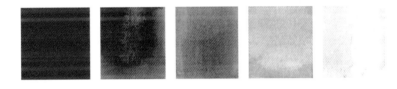

BRUSHSTROKES

As pictured in the Supplies section on page 17, there are a wide variety of brush shapes and sizes. For the activities in this book, you will need just a few simple types of brushes: a large brush, which can be flat or round; a medium-size round brush; and a liner brush for details. The large brush will be used to fill in large areas with paint and can be anything larger than a size 8. A medium-size brush can be useful when filling out smaller areas or detailing midsized textures. I like using anything from size 1 to 4 for this. For painting small details, you will want a brush that ranges between a 0 and a 000. This last type of brush is especially important for the artwork created in this book. Thin lines and small dots go a long way depending on how you apply them. You may also use a filbert brush, which is flat with a curved tip, for certain washes and details.

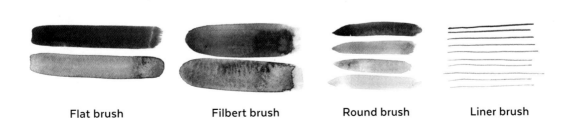

| Flat brush | Filbert brush | Round brush | Liner brush |

LAYERING

An important characteristic that makes watercolor so different from other mediums is its inability to layer light tones over dark tones. This transparent aspect of watercolor encourages us to get creative with the order in which we paint our layers. For best results, always layer from light to dark. Paint a first layer, let it dry completely, and add a second layer of paint over it. The layering of transparent pigments will alter the final outcome of the opacity and color. If we paint a light layer of blue over yellow, we will of course end up with green. The second transparent layer will not cover or hide the layer underneath completely.

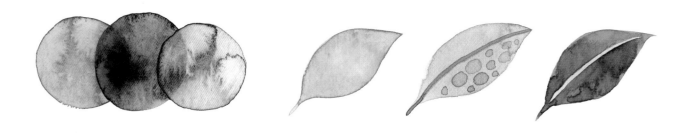

MIXING OTHER MEDIUMS WITH WATERCOLORS

Watercolor works well with a variety of mediums, such as ink, pens, and colored pencils, for details. In this book, I demonstrate how to integrate these tools to create fun and dynamic textures.

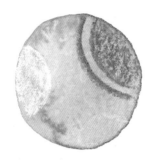

Colored pencils

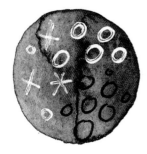

Gel pens and ink pens

Metallic paint and gold gel pens

Opaque white ink

SUPPLIES

PAPER

Using the right type of paper is fundamental when using this medium. Please make sure you are using watercolor paper and not mixed-media or drawing paper. The amount of water used is too heavy for any inadequate paper to handle. Luckily there are many options that are widely available at art supply stores or online. I recommend using heavy paper, at least 300g/m^2 (grams per square meter) or 140 lb. Watercolor paper typically comes in three different textures: rough (very textured), cold press (less textured), or hot press (smoothest). Texture is truly a personal preference, and each artist will find what works for them through experimentation. If you are new to watercolor, Canson XL is a good brand to start with. It is quite affordable and easy to manage. For special pieces, I prefer using Arches or Winsor & Newton professional-grade paper.

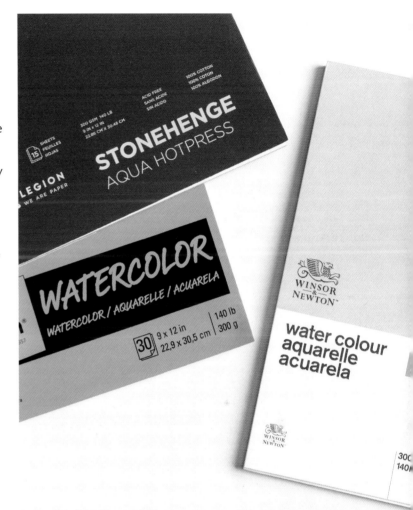

BRUSHES

Brushes come in all shapes, bristle types, and sizes. In this book, I mostly use Princeton and Winsor & Newton synthetic watercolor brushes. For the projects in this book, simple round brushes are mostly all you need. I suggest always working with at least three different sizes, for example a size 10, 2, and 00.

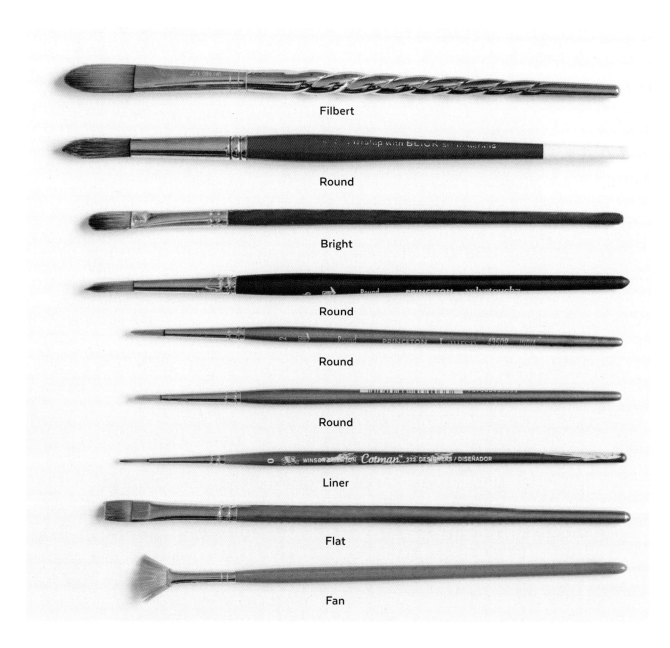

Filbert

Round

Bright

Round

Round

Round

Liner

Flat

Fan

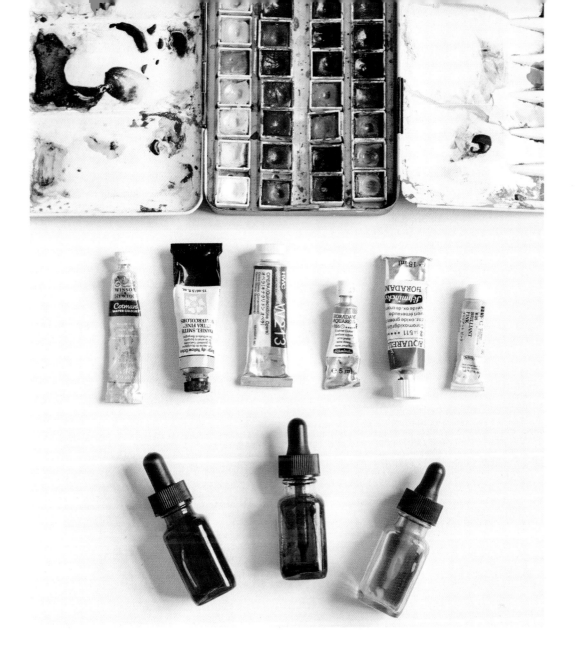

PAINT

Watercolors come in three main formats: tubes, pans, and liquids. The way I like to work is to have a large pan set as my main palette and mix in special colors from tubes and liquids that don't typically come in a pan set. This way I can achieve a unique color palette that represents my artistic style best.

My recommended brands are Winsor & Newton, Schmincke, Sennelier, Daniel Smith, Dr. Ph. Martin's, and Holbein, to name a few. I have added a full list of brands with their corresponding websites on page 134.

If you are just starting out, you don't need anything too extravagant—many high-quality brands have student-grade paints. Winsor & Newton's Cotman line, for example, will be a more accessible option. The pigments used are still fine-art grade, but the pigment load is lower. As a working artist, I have spent years collecting watercolor paints, but in my first three years of painting, I only had one Cotman half-pan set, and it was more than enough to keep me engaged with my painting practice on a daily basis.

BASIC TOOLS

Here is a list of basic tools any art studio should have (see below, clockwise from top left):

- Water cup (A)
- Paper towel or cloth (B)
- Dropper or artist pipette (C)
- Mixing palette (D)
- Washi, painter's, or masking tape (E)

- Pencil, sharpener, and eraser (F)
- Ruler (G)
- X-Acto or utility knife (H)
- Scissors (I)
- Some sort of adhesive or glue stick (J)

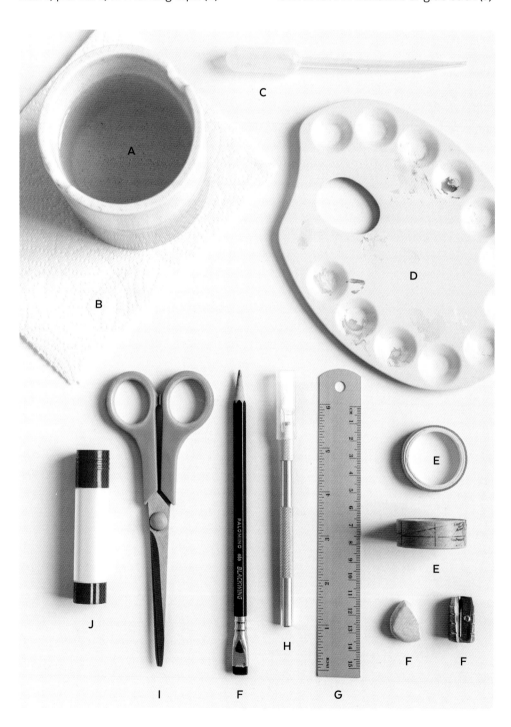

ALTERNATE DRAWING TOOLS

In this book, I demonstrate different methods of creating textures with watercolors. Using pen and drawing mediums are a favorite when it comes to adding final details to textured artwork. The contrast between the watercolor washes and the bold pens and pencils makes the paintings really pop. Here are a few I enjoy working with:

· **Gel pens.** These come in many colors, but white is the one I go to most often. Sakura Gelly Roll pens are widely available and affordable.

· **Uni-Ball Signo Gel Impact Pens.** These are extraordinary pens. I especially love their white, silver, and gold.

· **Pilot metallic paint markers.**

· **Colored pencils.** My preferred brands are Prismacolor, Derwent, and Caran d'Ache.

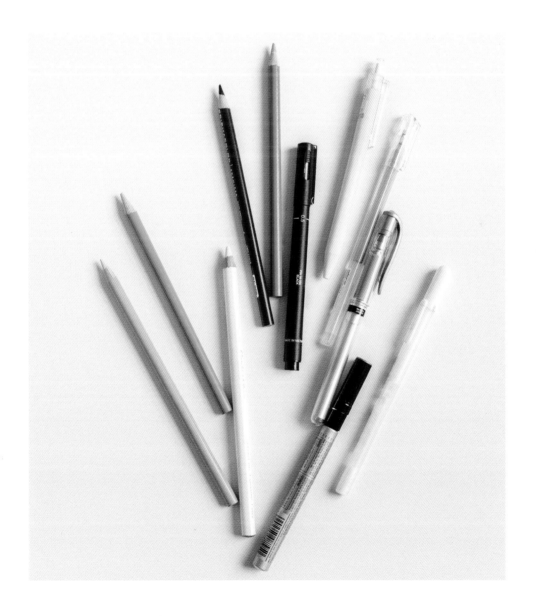

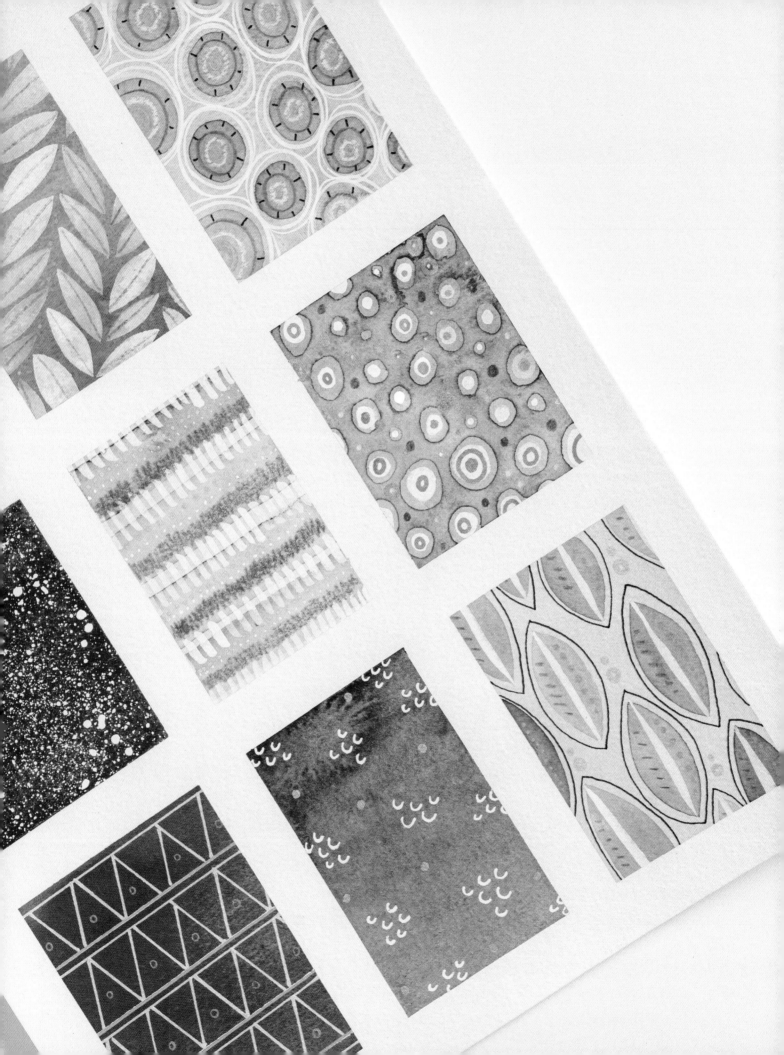

TEXTURE SWATCHING

Now that you have some basic watercolor knowledge and all the tools at hand, you are ready to dive right into painting! I am going to start off by demonstrating a few very simple textures. My goal as an art educator is to encourage artists at any level to take a close look at complex artwork and deconstruct it so it is simple enough for anyone to apply.

In this chapter, I demonstrate three different ways to add texture to watercolor washes. I use rectangle washes as a base and layer details, mostly consisting of circles and lines. If we take circles or dots as an example, on many occasions, the variables are size, rhythm, repetition, and spacing. These variables are enough to create large differences in the final look of each texture.

WET-ON-DRY TEXTURES

Wet-on-dry is a simple way to add details to watercolor paintings. It consists of painting an initial layer of paint (or wash), which will usually be quite light and somewhat watered down, waiting for this layer to dry completely, and then adding detailed paint strokes as a second layer. It's important to let the first wash dry to prevent bleeding between the first and second layer. Some artists will use a tool similar to a hair dryer to quicken the process, but I have always preferred to let the paint dry on its own.

This particular technique is especially useful when painting thin lines or detailed figures in general. If your brush is thin enough or you practice brush control, you can achieve extremely precise textures.

1. To prepare the swatches, divide your paper into nine sections using washi, painter's, or masking tape. Fill in all the sections with transparent washes. The best way to achieve this light consistency is by adding clean water to your palette and mixing in a small amount of paint to create watered-down pigment. Fill in all the rectangles with the colors of your choice.

2. Your first layer of texture swatches is ready! Let this dry completely before continuing to the next steps.

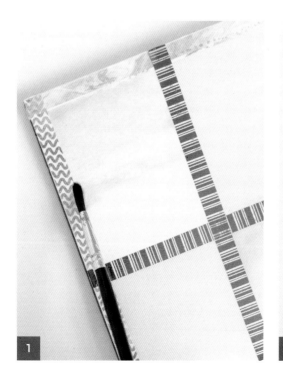
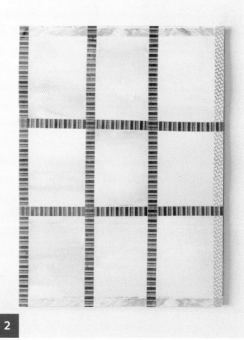

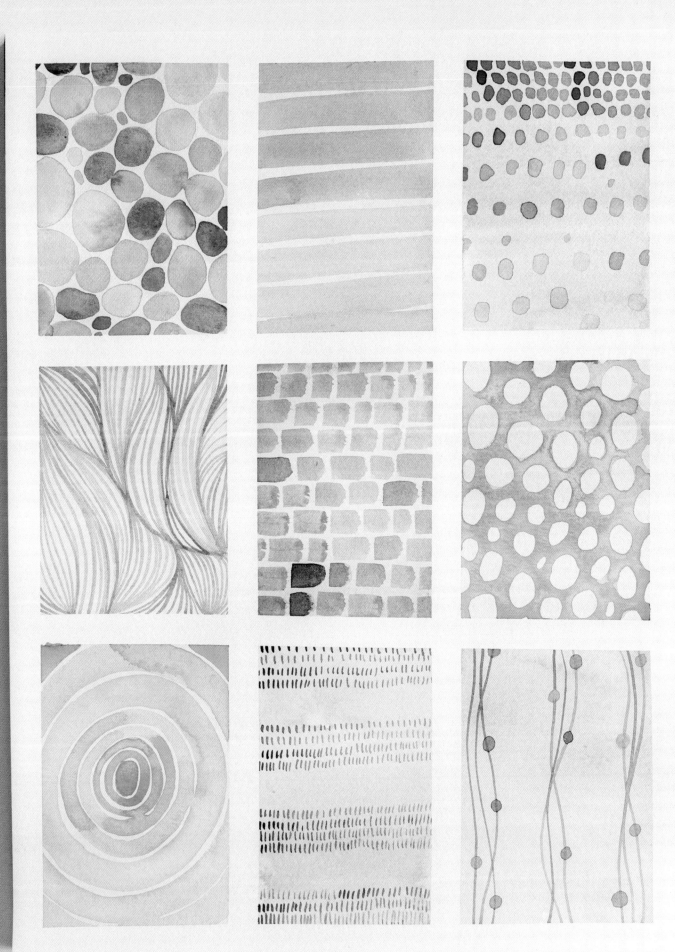

PEBBLES

1. Create a mix of paint and water that is more concentrated than your first layer. The opacity is up to you—a darker tone will add more contrast, while a lighter tone will be more subtle. Either way works. Texture swatches are the perfect opportunity to play and experiment. I am using Cascade Green by Daniel Smith here because it is such a magical tube of watercolor! The pigment separates as it dries, so some areas look green and others look turquoise.

2. Paint different-size circles all around your selected area. I like to keep the circles pretty close together. Spreading them out more would be fine too, but the pattern would be different.

3. Continue painting until the area is covered with circles. I aim for having some circles be darker than others by adding a little extra paint. This variety in value makes watercolor so interesting to look at.

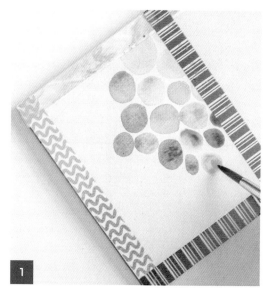

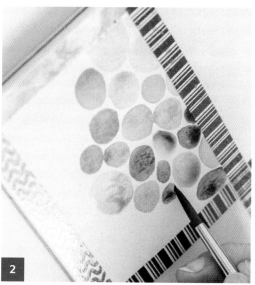

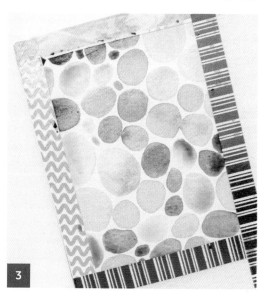

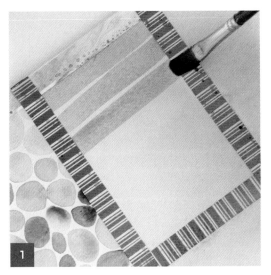

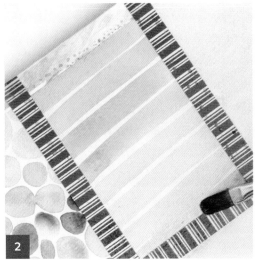

STRIPES

1. Use a flat brush for this texture. The size of your brush will determine the width of the stripes.

2. Continue painting horizontal stripes, trying to keep the same distance between each stripe. This is also an excellent way to practice your pacing and precision.

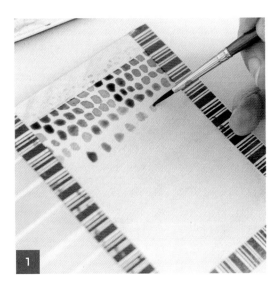

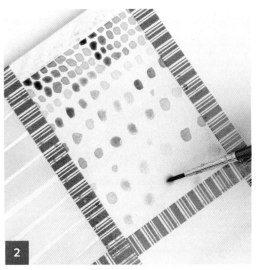

DOTS

1. Use a medium to small brush to paint irregular dots on the next section.

2. This is a great way to practice repeat textures and rhythm. The pattern can vary so much, depending on how much space you leave between each element.

SWOOSH

1. Paint a curved line in the center of your rectangle. The best brush to use for painting long continuous lines is called a liner brush. Liner brushes are thin and have longer bristles, which hold more paint. This will allow you to paint thin lines without running out of paint midstroke. Repeat the initial curved line as demonstrated for a few strokes.

2. Paint another curved line going in a different direction, and continue to paint thin lines, following the direction of the curve.

3. Keep adding curved lines around your painting area. This is great practice for painting hair texture.

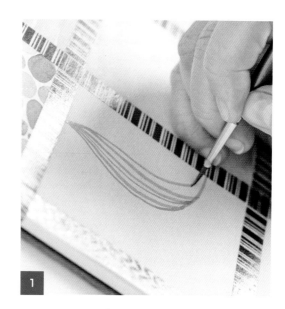

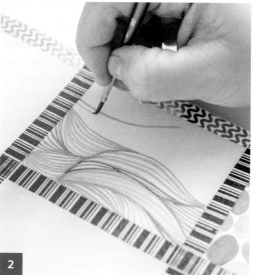

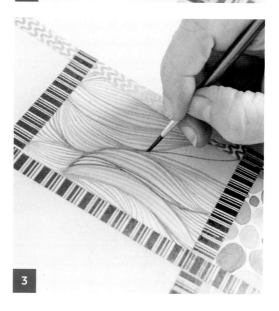

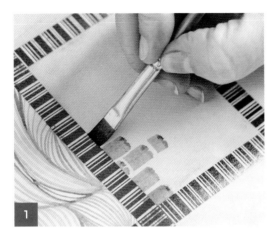

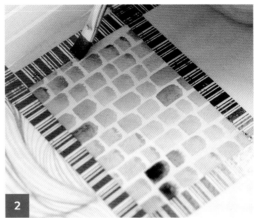

BRICKS

1. Using a flat brush, paint short rectangular strokes.

2. The second row should start at the halfway mark of the bricks on the top row to give the illusion of a brick wall.

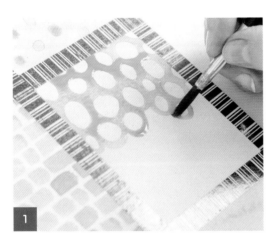

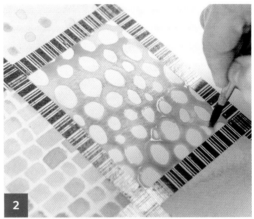

BUBBLES

1. This style of painting is considered to be "negative painting" in watercolor, which means you are painting around a selected area in a darker color to reveal the lighter color of the bottom layer. This texture is something like the inverse of the Pebbles texture demonstrated on page 26. It consists of painting circles that are close to each other but filling in the space between the circles instead of the circles themselves. A medium-size brush is great for this technique because it offers good control over the shapes and holds enough wet paint for continued painting.

2. It's important to keep your paint area quite wet with this technique, as you want your brushstrokes to blend together so the texture looks seamless.

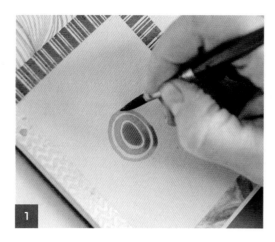

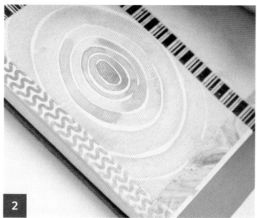

CONCENTRIC CIRCLES

1. Begin by painting a small circle in the center of the rectangle using a medium-size round brush, and then paint rings around the circumference.

2. Continue to paint rings until you have reached the edge of the rectangle. The trick to this effect is to get each ring as close as you can to its neighboring ones without bleeding into them.

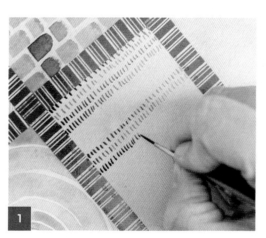

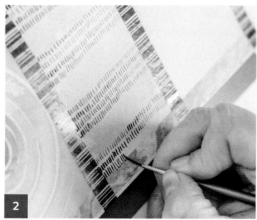

ETCHING LINES

1. This texture reminds me of etching or pen drawing, where entire areas are filled with very small lines to create the appearance of a darker surface. Use a liner brush to paint small strokes in horizontal rows. To make the texture more interesting, skip a gap, and continue painting the next rows.

2. The etching lines texture is great practice for painting furry animals.

WAVES AND BEADS

For most of these textures, we have been doing simple variations of lines and circles. This is a texture where you can experiment with mixing both. Use a liner brush to paint wavy lines. With a medium round brush, paint small circles in selected areas.

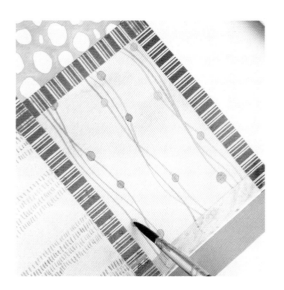

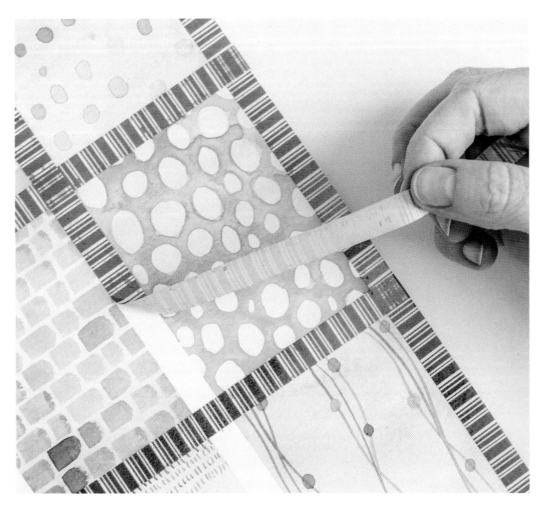

Here comes the fun part—once all your layers of paint have dried, lift up the tape to reveal the final painting! This is always so satisfying.

WET-ON-WET TEXTURES

Wet-on-wet watercolor painting is a technique that involves applying wet paint to a wet surface. It is commonly used to create soft, blended, and organic-looking washes of color.

THE BASIC TECHNIQUE

1. To use the wet-on-wet technique, first wet the paper with clean water or a light wash of watercolor.

2. Then, while the paper is still wet, apply more watercolor paint to the surface. The wetness of the paper causes the paint to spread and blend with the other colors on the surface, creating a smooth and flowing effect.

3. In this section, I demonstrate how to create four different wet-on-wet textures. To begin this activity, divide your paper into four rectangles with washi or painter's tape.

The wet-on-wet style is particularly useful when a soft, organic appearance is desired. By using this technique, you can create a dreamy effect that is difficult to achieve with other mediums. The wet-on-wet technique can be challenging at first. It requires a certain level of control and precision while simultaneously learning to let go of specific desired results. However, with practice and experimentation, you can create unique and stunningly beautiful watercolor paintings.

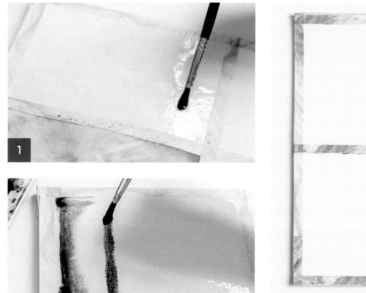

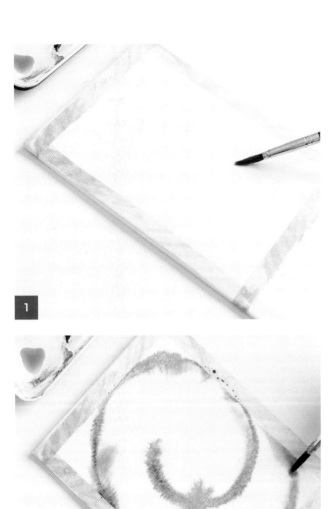

TIE-DYE

For a classic tie-dye look, I'm using a multicolor palette, although many color combinations would look beautiful. Regardless of the chosen color palette, make sure to prepare enough paint by mixing water with your concentrated paint in your mixing area. I also recommend having your colors picked out beforehand. This helps you add color quickly so your initial clear water layer doesn't dry while you're busy mixing more paint, allowing the colors to blend nicely on the wet surface. Time is of the essence when using the wet-on-wet technique.

1. Apply a layer of clean water onto your first section using a large brush.

2. Pick up some color with your brush. My first color is cyan. Paint a wide, open spiral that swirls around the wet area. The paint might bleed a bit more in some areas than others, and that is fine. Just make sure you have enough control of the paint so you can make out the spiral shape.

3. Repeat this step using another color to fill out an area next to the initial spiral with a neighboring spiral.

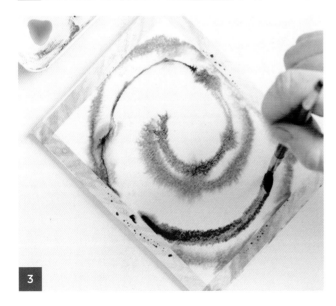

(continued)

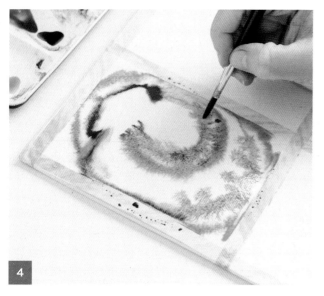

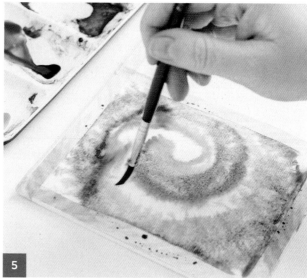

4. Use soft radial brushstrokes between neighboring colors to gently control the way the colors blend into each other.

5. Continue swirling around your initial shape using different colors. By this point, the colors will begin to blend together more, and you can continue to manually pull colors out slightly while the paint is still wet for a more dramatic effect.

6. Fill in your final color.

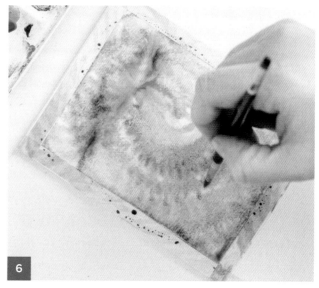

7. Clean and dry your brush. By this point, your paint will be slightly damp. Using your dry brush, lift up the paint with short strokes in between colors. This imitates the white areas where your fabric would be folded in traditional tie-dye.

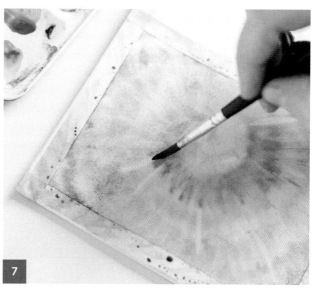

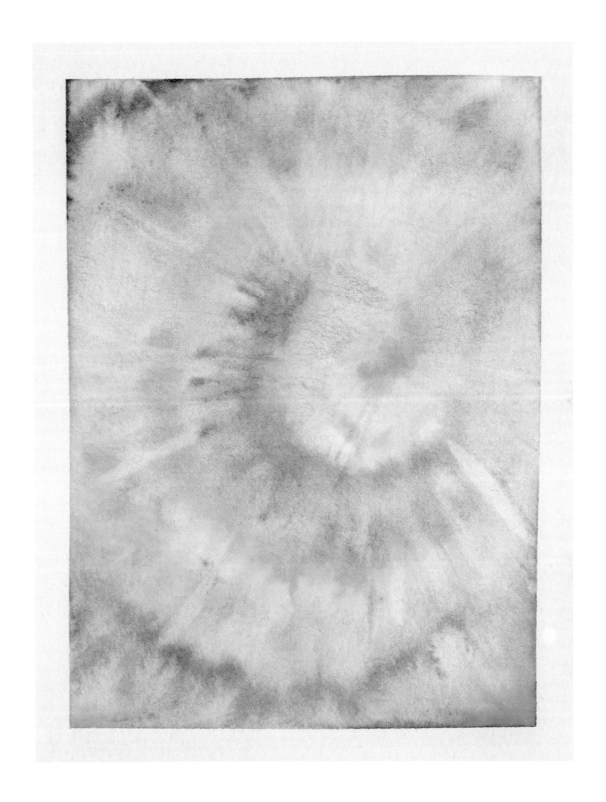

SHIBORI EFFECT

Shibori is a Japanese dyeing technique that produces patterns on fabric. I was inspired to call this texture swatch Shibori because the blue paint I selected is similar to the indigo dye that is traditionally used. This texture is considered monochromatic, as we are only using one color.

1. Brush a layer of clean water onto your paper.

2. While the paper is still wet, pick up concentrated indigo watercolor paint and add horizontal stripes across the painting area.

3. Continue in this way until you fill the entire area. If you feel there is too much water or paint in certain areas, you can always manipulate this while it is still wet, either by moving the water around with a brush, adding more paint, or lifting paint with a paper towel.

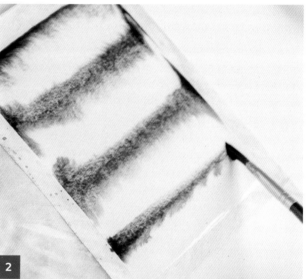

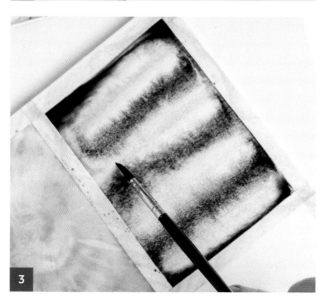

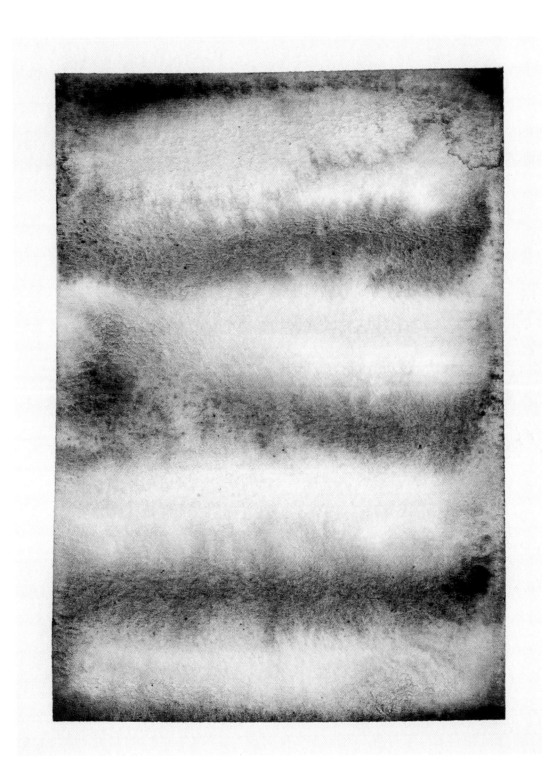

SNOWY SKY

Painting skies is full of possibilities, and there are so many fun techniques you can try when it comes to watercolor. In this case, I will demonstrate a simple way to re-create a cold winter night sky. If you use your imagination, you could also add stars for a galaxy painting!

Although this specific demonstration is not technically wet-on-wet, it is in this category because we are using the lifting technique on wet paint, as opposed to adding more paint to a wet surface.

1. Paint the entire area using a concentrated mix of paint. I am using a blend of violet and ultramarine blue because I want the paint to be dark enough so the snow details will be more noticeable later on.

2. While the paint is still wet, use a cotton swab to create little snowflakes by lifting up the paint. The more pressure you apply, the whiter the area will be. You will probably need three or four cotton swabs, because the cotton absorbs quite a bit of paint, and the effect dulls the wetter the swab gets.

3. Continue lifting paint from your surface. The idea is that some circles will be more subtle than others, giving the appearance of depth.

4. Feel free to play around with your cotton swab. I added a few swirls and concentric circles around some of the snowflakes. Texture swatches are for experimenting and trying new ideas out on the whim. They're a great opportunity to just play!

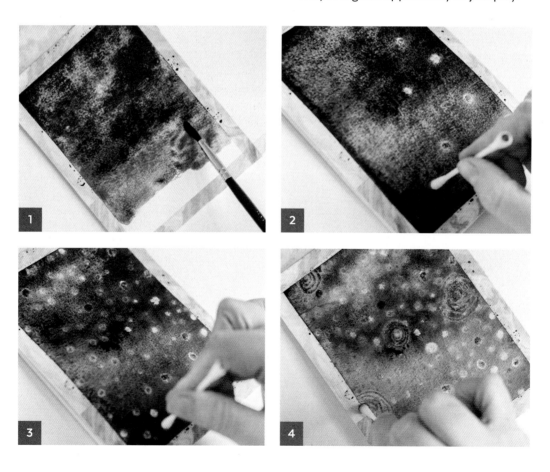

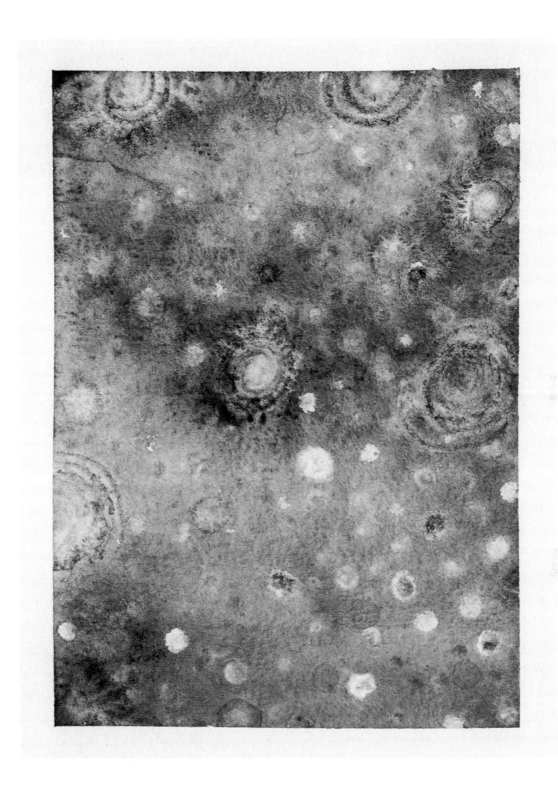

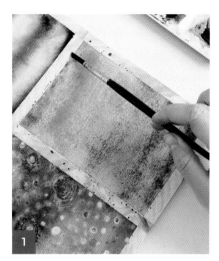

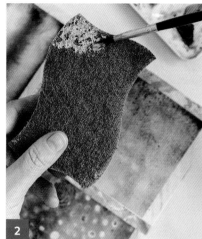

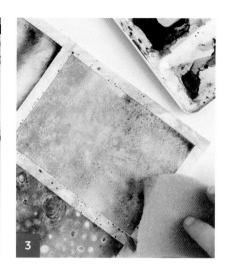

MOSSY GREEN

A combination of warm, bright greens with ochre is perfect for an inspired fairy garden texture. Applying watercolor is not limited to brushes, and there are a number of everyday tools you can use to create interesting textures. Sure, there are tons of fancy art supplies that are wonderful, but even something as simple as a kitchen scrubby sponge can create interesting works of art.

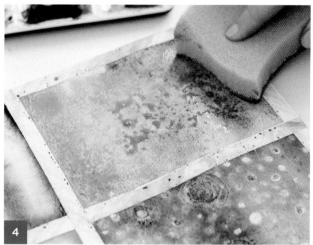

1. Start by painting the area with a variety of greens. You can mix different tones while the paint is still wet for an effortless wash. Use plenty of water and pigment, as you want this area to stay wet for a while so the texture can blend in nicely.

2. While the green paint is still wet, apply some yellow paint to the rough side of your sponge.

3. Dab the yellow paint over the first layer of green watercolor.

4. Repeat step 3 with ochre paint.

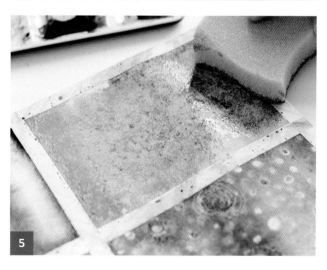

5. Using a clean area of your sponge, pat the wet surface to make the texture more seamless, until you feel it looks right.

MIXED-MEDIA TEXTURES

Watercolor paints mix incredibly well with other mediums, especially when it comes to layering pens, markers, or colored pencils over a wash. Once the paint has dried, the paper remains easy to work with because of the paint's simple composition. Watercolor paints are made out of just a handful of ingredients: pigment, a binder formula, and water, which eventually evaporates, leaving the actual texture of the paper similar to its original state.

I love using pens for details because of the amazing precision they allow. They are opaque, which allows you to paint lighter colors or metallics over any type of watercolor wash. When painting with watercolors exclusively, we are bounded by the "only layering dark layers over light layers" rule. Using opaque mediums gives us freedom to think outside this traditional way of painting and layer details over darker colors too.

Prepare your swatches by separating sections with tape and painting each area. In this case, I encourage you to paint some of the areas with light washes. Others can be darker and more opaque. I chose earth tones for this swatch exercise (see below and opposite).

Prepare your supplies. Feel free to use any of the Alternate Drawing Tools listed on page 21 and others. This is a great opportunity to try out any interesting supplies you might have on your worktable.

In this section, I share ideas on how to create different textures by type of material as I paint around all the swatches.

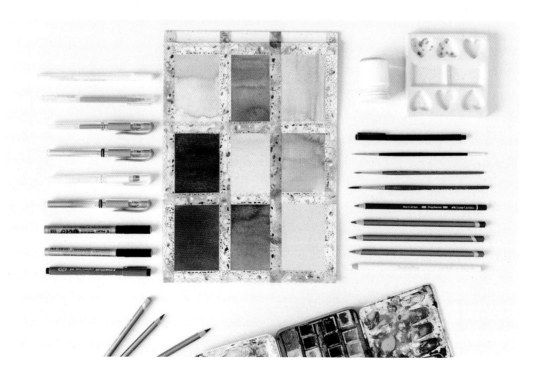

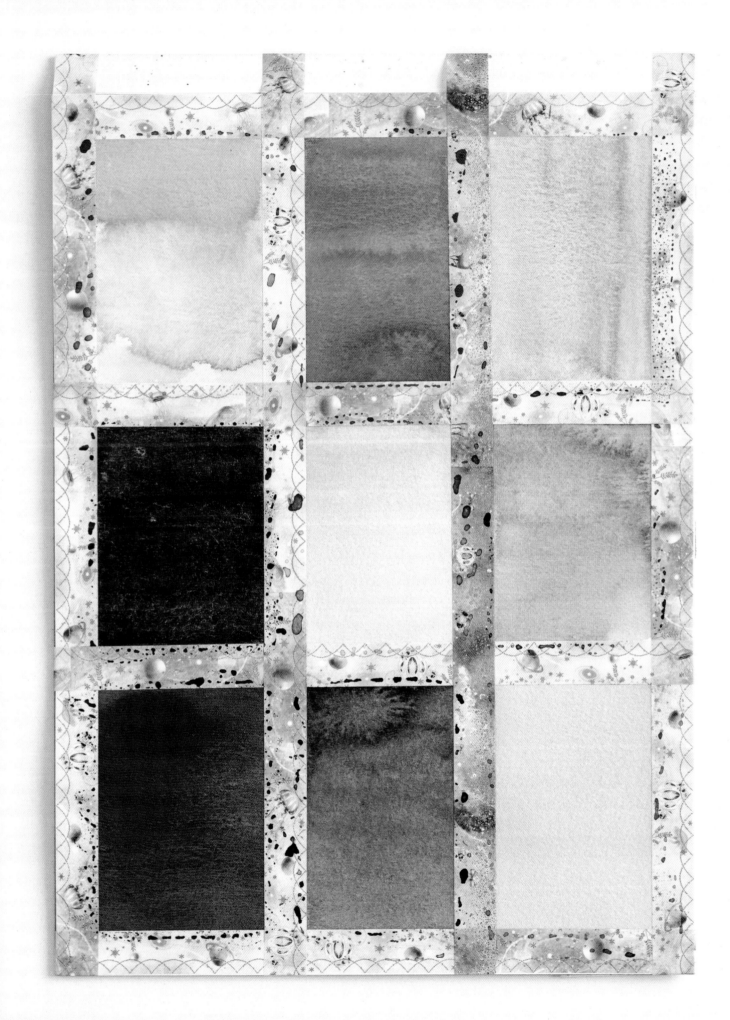

WET-ON-DRY WATERCOLORS

Paint details over some of the rectangles using the wet-on-dry technique, focusing on the lighter rectangles. Some detail ideas are lines, bars, geometric leaves, circles, stripes, and bubbles.

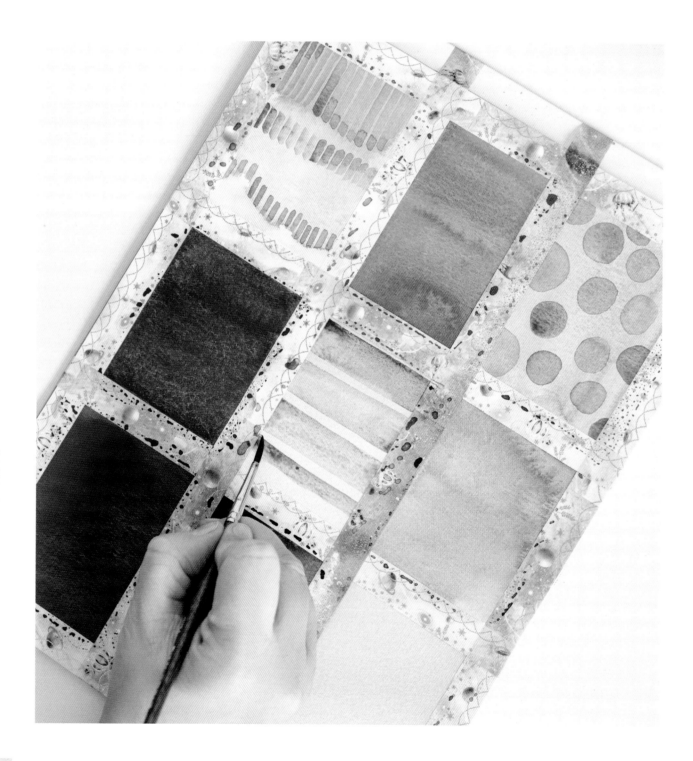

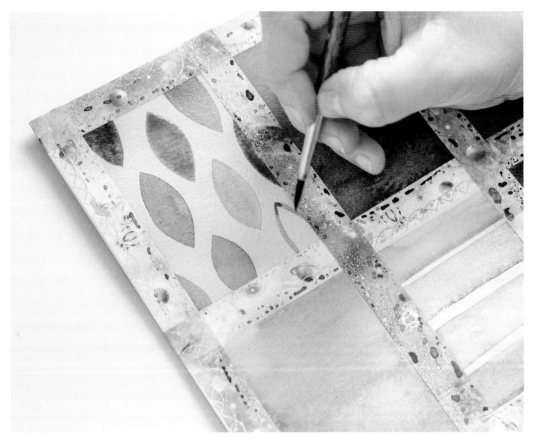

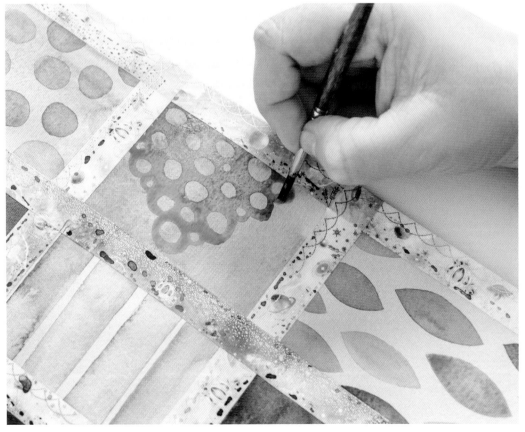

WHITE INK

White ink works wonderfully with watercolors because it is opaque but has minimal texture. Ink can also become transparent when water is added.

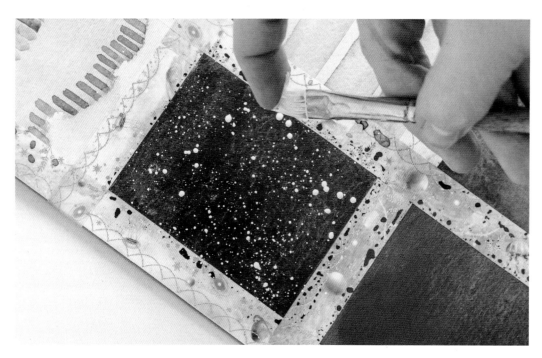

Splatter white ink with a flat brush or toothbrush. I like doing this effect over black or dark blue for a starry-night texture.

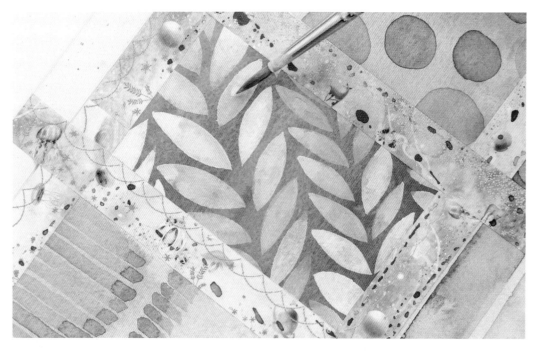

Water down the white ink and create simple leaf shapes arranged in a geometric pattern.

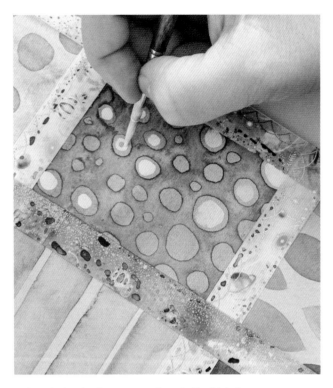

Paint circles in the center of each "bubble."

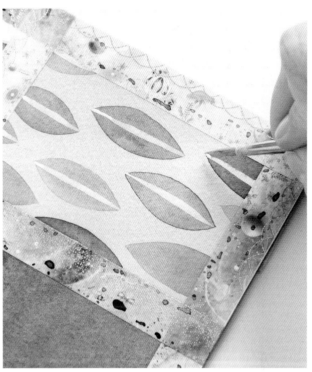

Add vertical lines across each leaf.

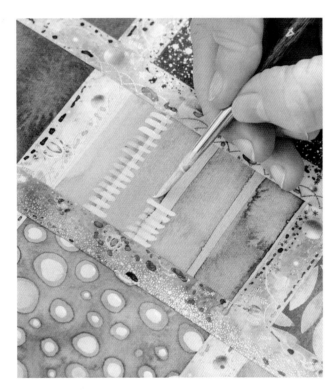

Connect each bar by "stitching" the shapes together with smaller lines.

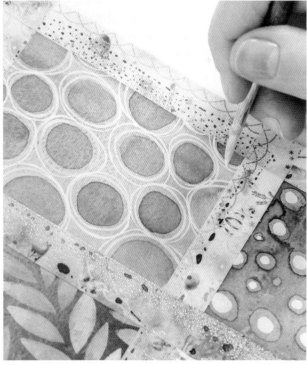

Outline the large circles with a small round or liner brush.

COLORED PENCILS

Draw lines, dots, zigzags, scribbles, and other fine details over the dry paint using a white colored pencil or a variety of darker colors for contrast.

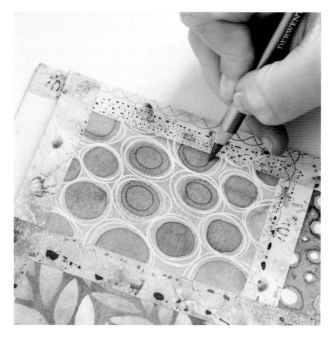

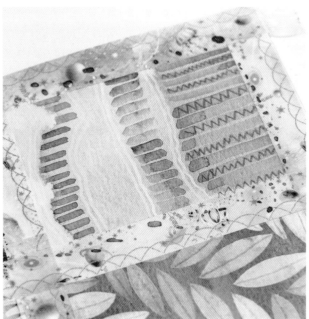

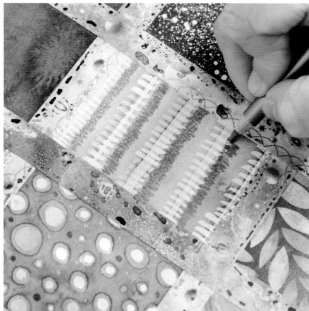

WHITE AND BLACK PENS

Add even more details using white gel pens and black drawing pens or thin markers.

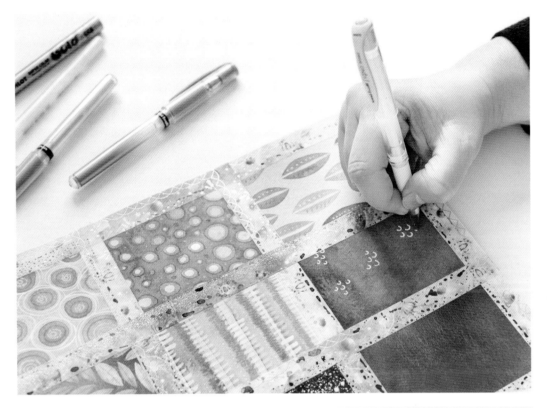

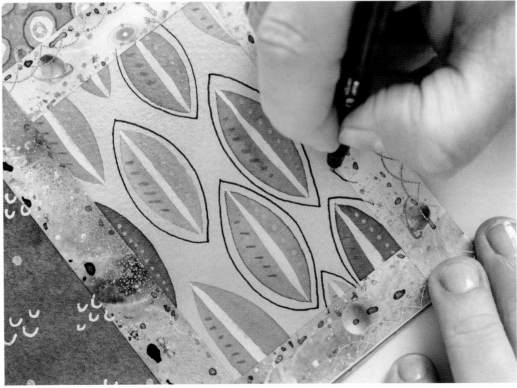

METALLIC PENS

Use gold, bronze, silver, or pearlescent pens. I recommend leaving these for last because it's difficult to layer over a reflective area, so these details will be the final touch to your mixed-media textures. Draw dots and lines to accentuate existing textures and patterns.

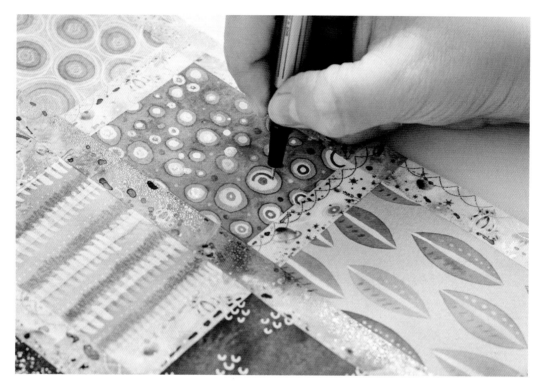

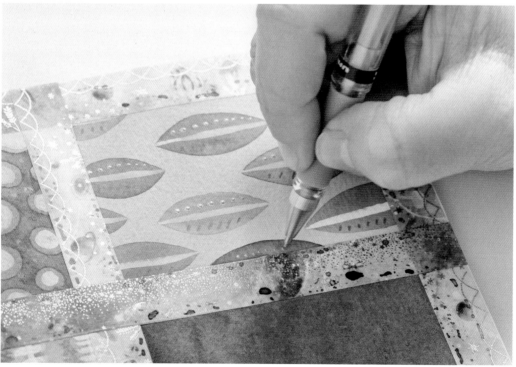

GEL PEN AND RULER

I left one rectangle for last to create a simple geometric pattern using a ruler and gel pens.

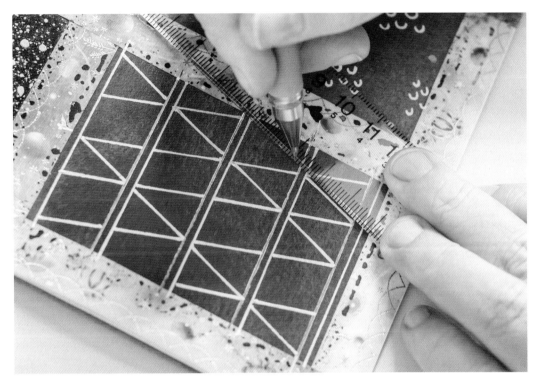

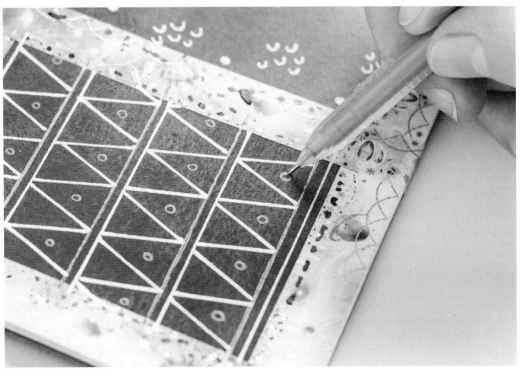

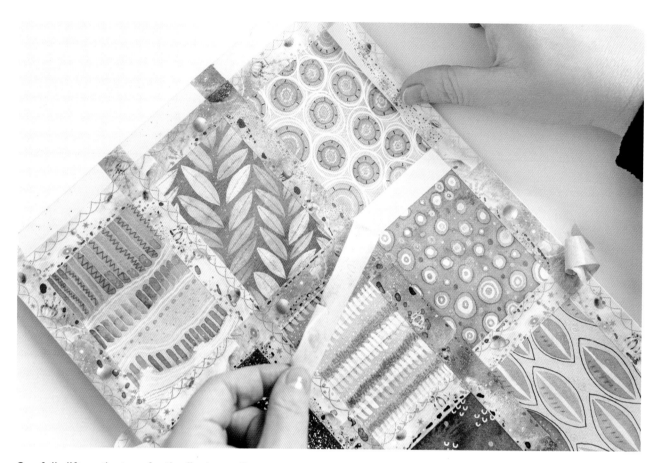

Carefully lift up the tape for the final reveal!

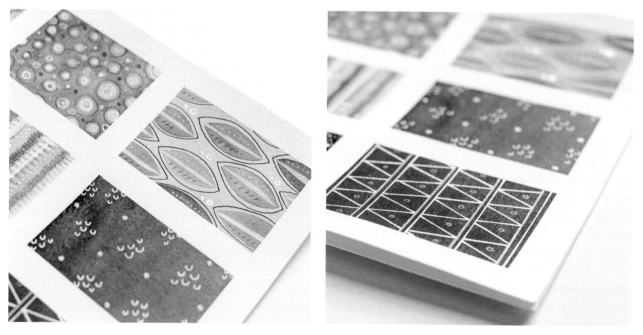

Metallic details shine when you angle the paper to catch the light reflecting off the paint.

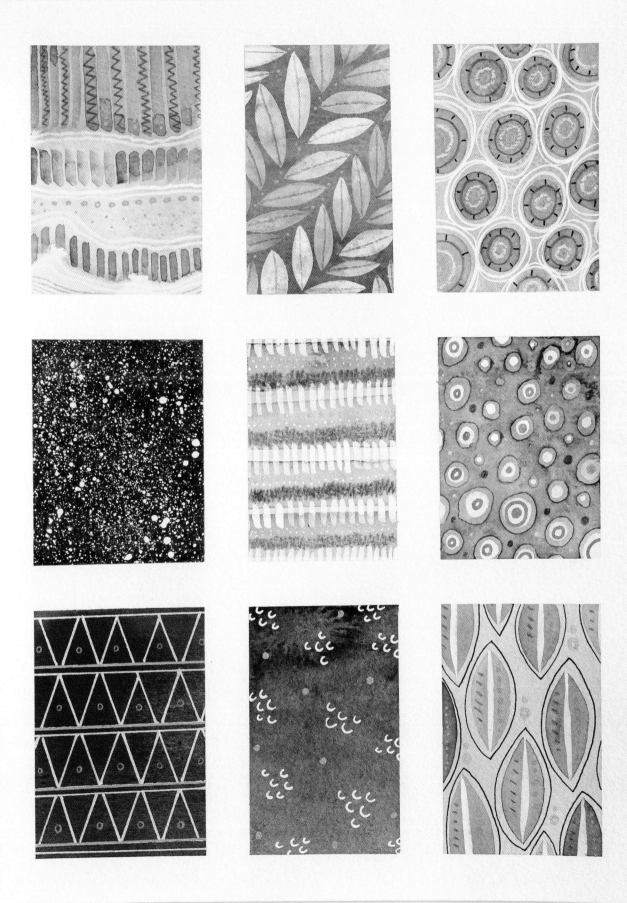

INSPIRED TEXTURES

Texture provides a wonderful layer of detail to any painting or illustration. In fact, there are many reasons artists add texture to their work:

- To define and enhance the object's surface, giving it a tactile quality

- To create the illusion of three-dimensionality, adding depth and volume to the artwork

- To differentiate one object from another

- To increase visual interest and contrast within a piece, making it more engaging and dynamic

- To establish and reinforce an artist's unique style, adding a distinctive character to their work

- To integrate different elements within a piece and create a sense of balance and continuity

- To convey narratives, ideas, and emotions, using texture as a storytelling tool

- To influence the overall mood and feeling of the artwork, creating a sensory experience for the viewer

CREATIVE CHALLENGE

Observe your surroundings and analyze objects, nature, the clothes you are wearing, the furniture in the room. . . . Everything around you has some sort of texture or pattern if you look close enough.

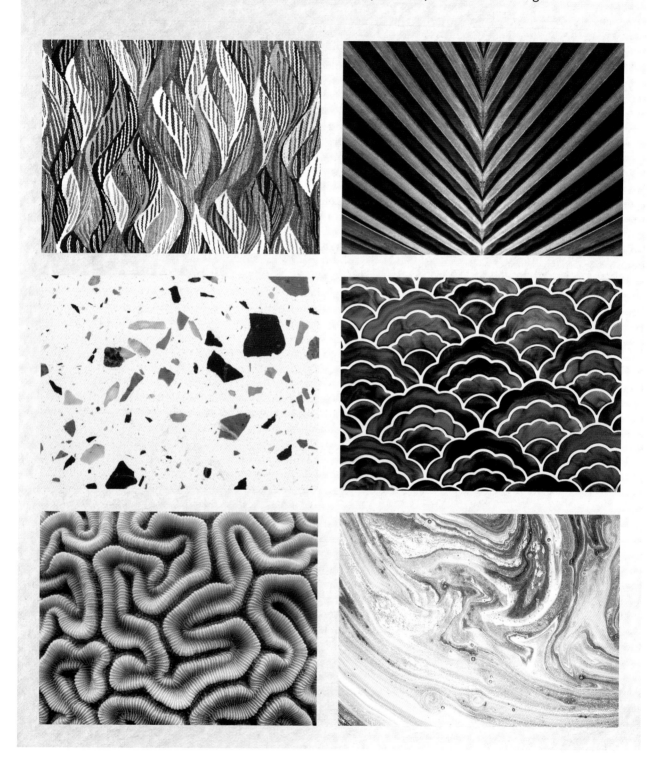

Use wet-on-wet or wet-on-dry techniques, or detail your art with other mediums to replicate these textures. Think of these inspired texture swatches as a collection of ideas to enhance your artwork in the future. They do not have to be exact replicas of the reference image. This is merely an exercise to improve your observation skills while practicing painting techniques. Use the instructions in the previous chapter as a reference for these swatches.

In the following pages, I share some images that interested me and how I interpreted them as references for possible artwork integration.

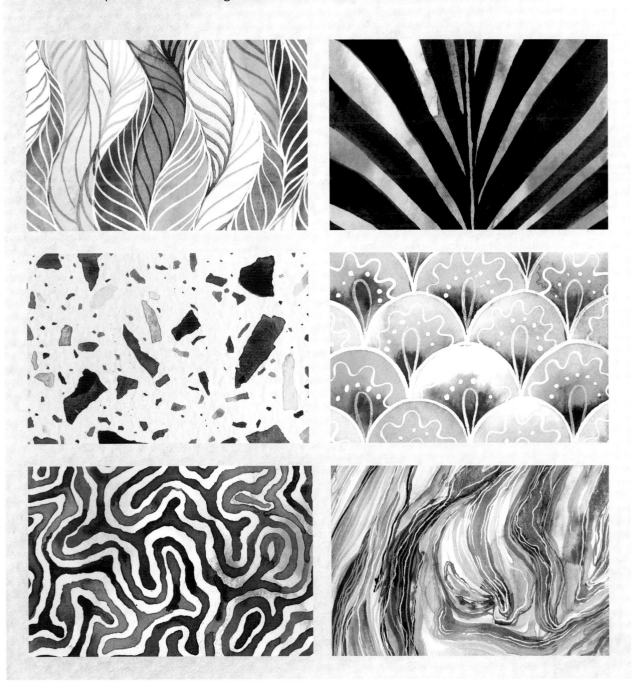

NATURE

CALM OCEAN

Technique: Layering wet-on-dry brushstrokes.

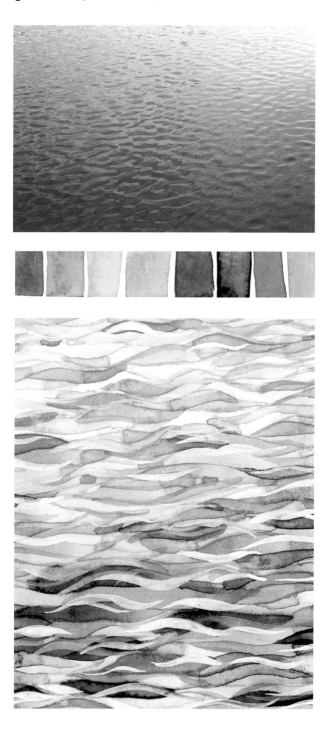

LEAF BLADE

Technique: Negative space layering of dark paint over dry light paint.

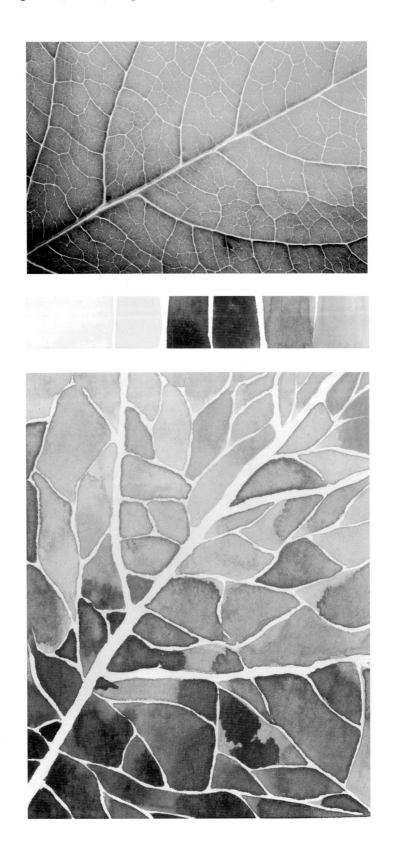

CULTURE

TALAVERA TILE

Technique: Wet-on-dry painting.

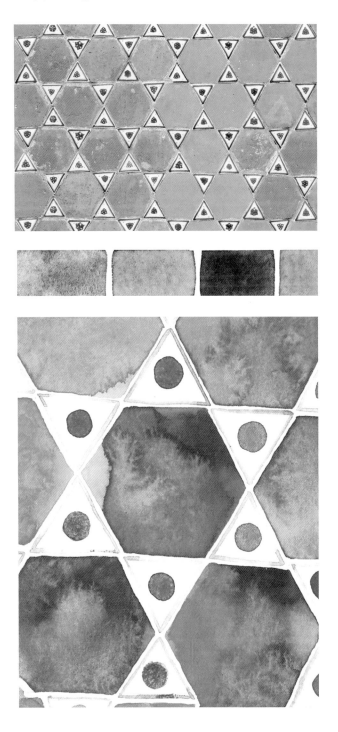

JAPANESE WAVES (SEIGAIHA)

Technique: Wet-on-dry painting with white ink details.

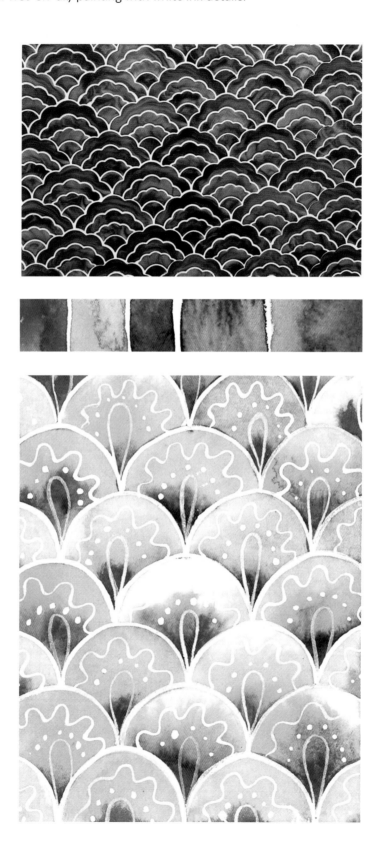

MOROCCAN RUG

Technique: Wet-on-dry with liner details.

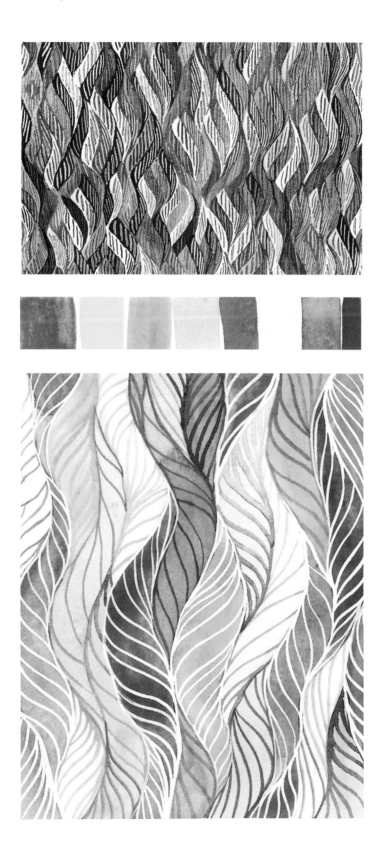

FESTIVE SARAPE

Technique: Wet-on-dry painting.

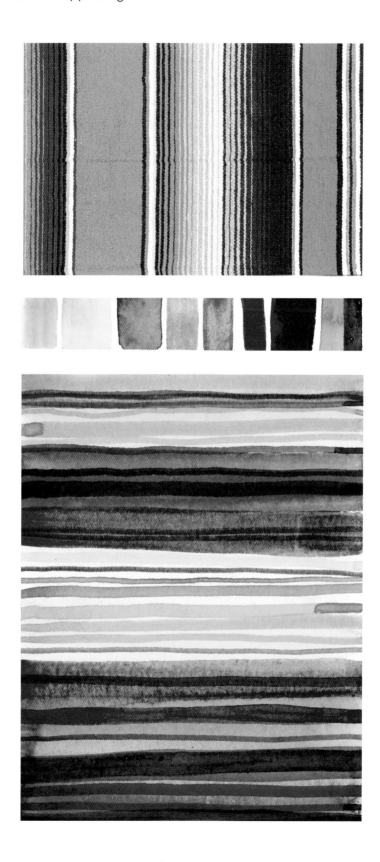

THAI FABRIC

Technique: Wet-on-dry layering.

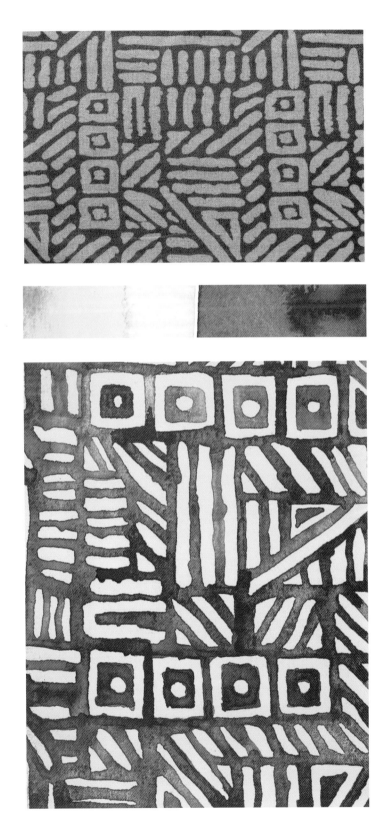

GHANAIAN TEXTILE

Technique: Blocks of wet-on-dry painting.

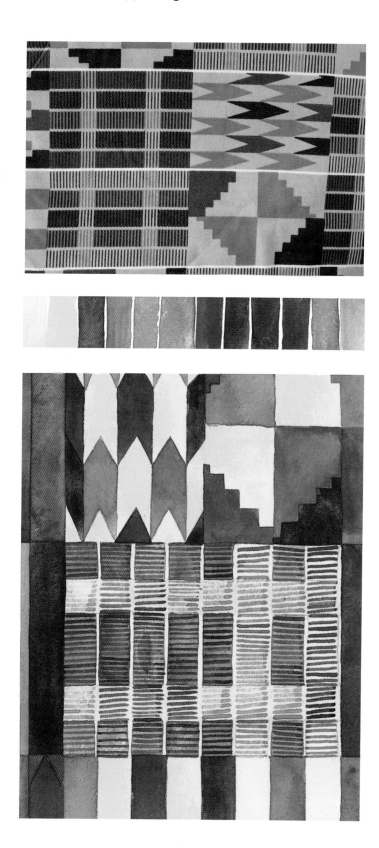

ABSTRACT

MUSEUM GEOMETRIC STRUCTURE

Technique: Wet-on-dry with white pencil details.

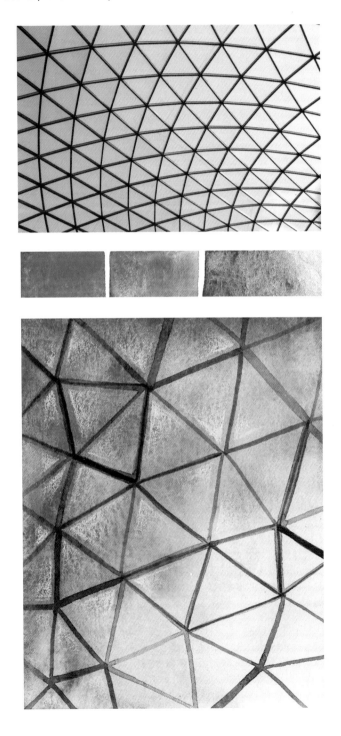

HOLOGRAPHIC SHINE

Technique: Wet-on-wet wash over clear crayon scribble.

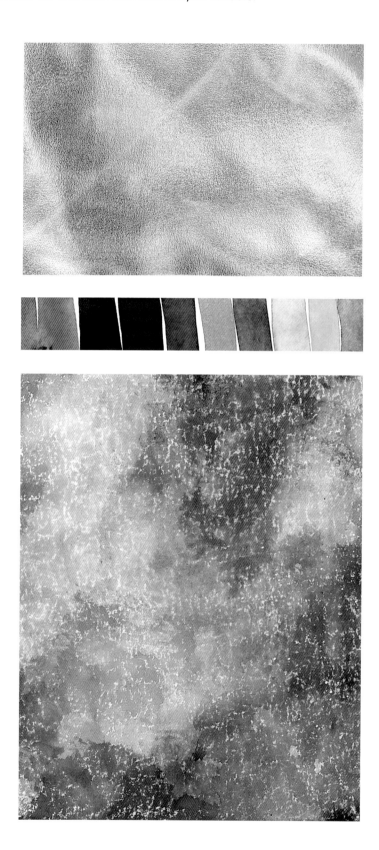

STONE TERRAZZO

Technique: Layering paint wet-on-dry.

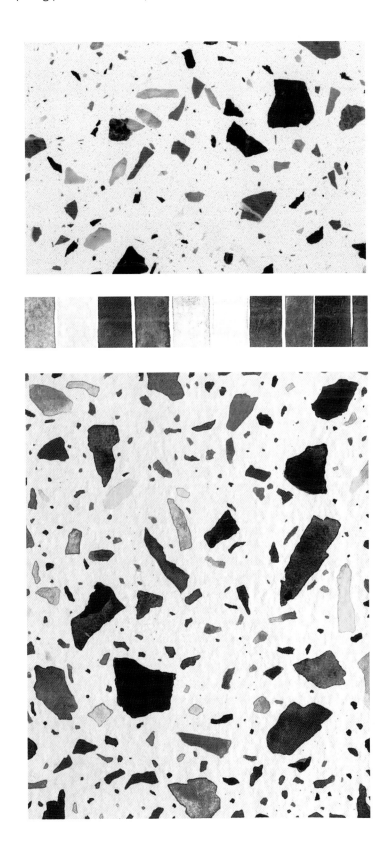

SWIRLING MARBLE

Technique: Wet-on-dry with gold pen and metallic watercolor.

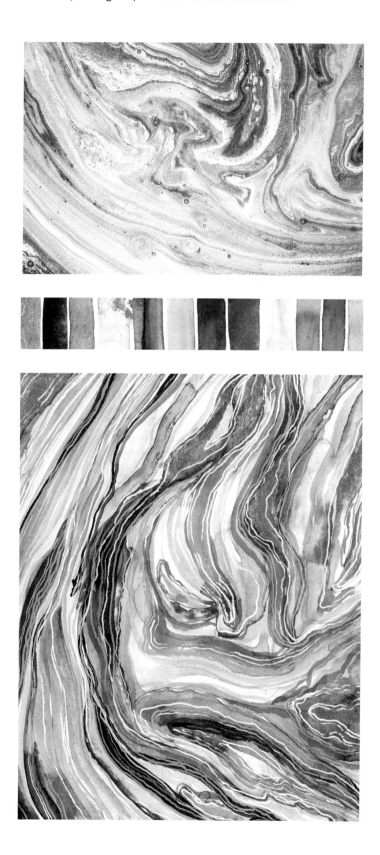

Creating texture studies is a wonderful way to get the creative juices flowing, which is perfect for those days when you are facing a bit of a creative block. They can lead to new ideas for interesting subject matters for full-scale paintings.

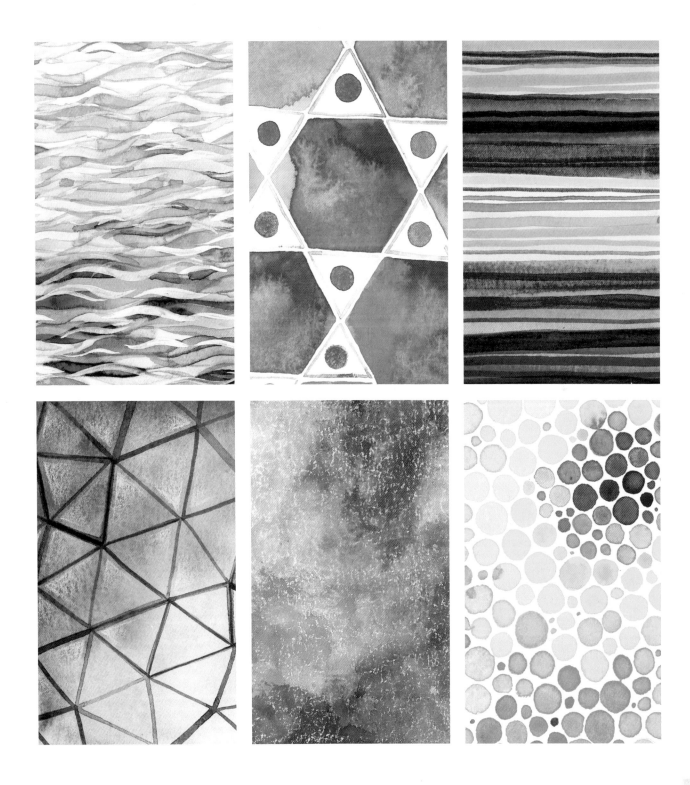

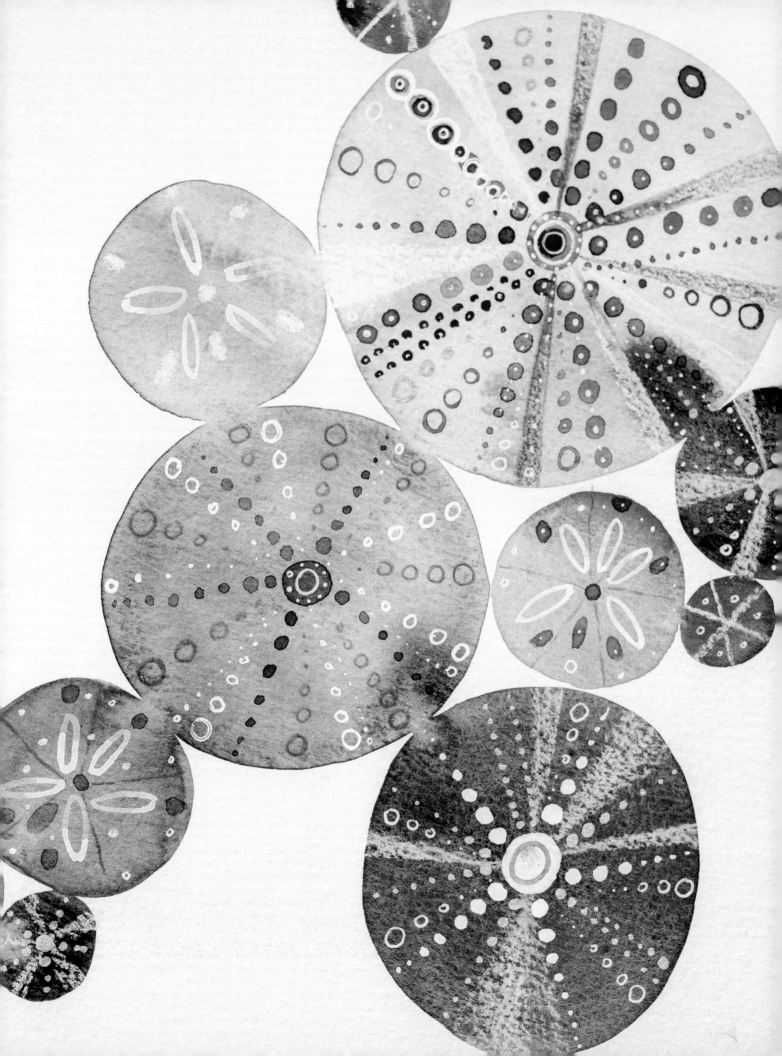

MINDFUL PAINTING

Over the years, I have been moved by countless students' stories about how watercolor has played an important role in their personal healing process. I include myself in this group. Their painting practice has helped them overcome complicated times by providing a space for calmness, reflection, and contemplation. In today's fast-paced world, it's been heartening to hear students say how simply slowing down for a moment to use their hands in a creative way has had such a positive impact on their well-being. It's clear that painting offers more than just an artistic outlet—it can truly be a powerful tool for self-care and personal growth.

Painting with watercolor requires being present in the moment and paying attention to details while letting the colors simply flow into each other. This unique combination can promote a sense of inner peace, and the repetitive nature of texture is especially good at promoting mindfulness.

In this chapter, I share a series of simple but stunning watercolor paintings with calming characteristics.

PINE FOREST

1. Prepare your paints with a series of greens you would like to use. You can also mix blue and yellow for a wide variety of tones. Paint a series of triangles in rows using watery paint for a transparent effect (1a), outlining each shape first if desired (1b). Let dry.

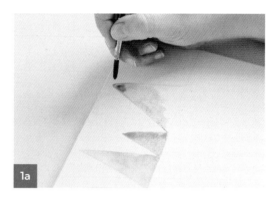

2. Using a medium to small round brush with a fine tip, or a liner brush, paint different designs on each pine tree using the same tones as the original layer of paint (2a). You can use a more concentrated mix for these details for more contrast (2b).

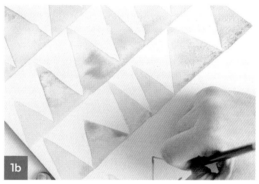

3. This is a direct application of the wet-on-dry texture exercise, so if you are feeling your line work needs improvement, go back and practice those texture swatches. They are a great way to play around and master precision skills while testing out new ideas!

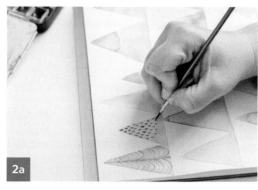

4. This simple painting can be complete as is, or for more fun, add stars over each pine tree for a beautiful handmade holiday card.

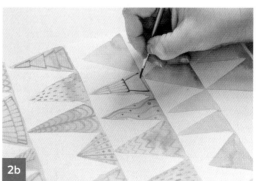

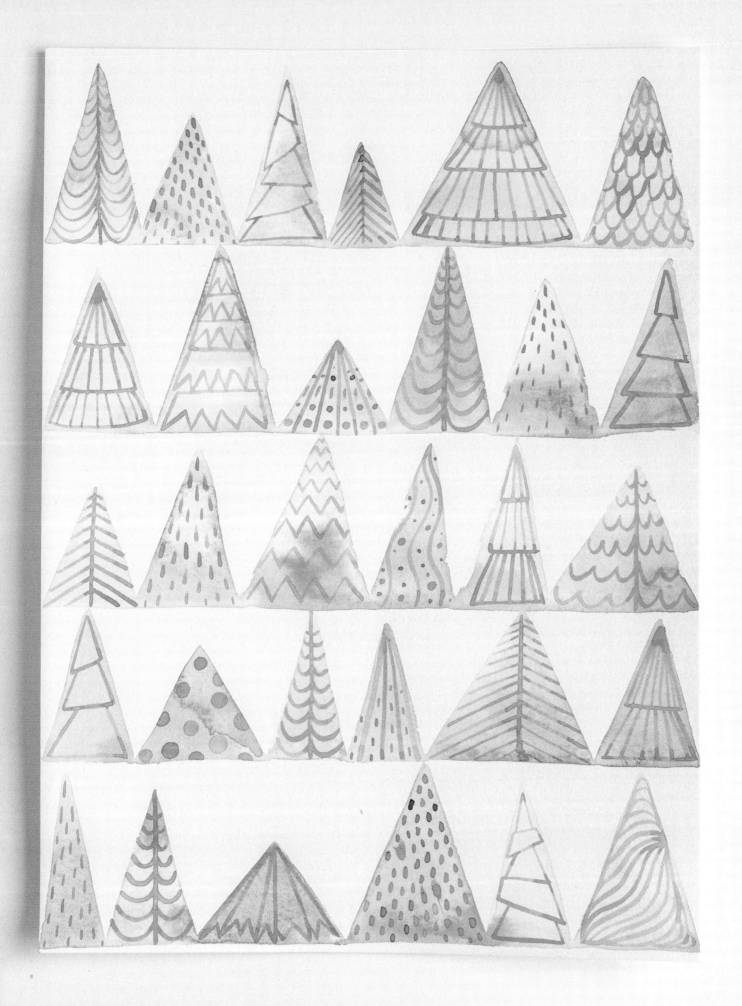

TRANQUILITY STONES

1. I chose a cool color palette with a variety of blues to express a sense of serenity.

2. Paint irregular round shapes using watered-down paint mixtures to create light shapes. Add more paint to the mixture to create darker shapes.

3. Look back at the wet-on-dry textures in the previous chapters to find inspiration. I'm painting curved irregular shapes with the same blue tones in this example.

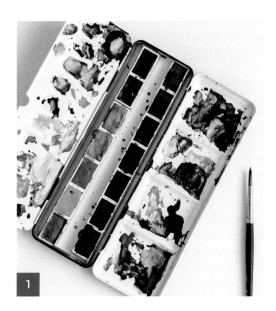

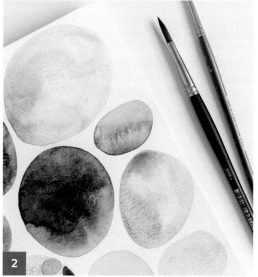

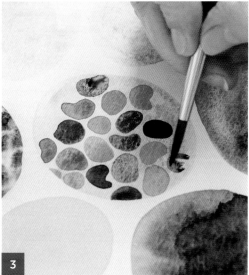

TIP: To get a wider range of effects, you can also paint some stones using wet-on-wet techniques (see "Wet-on-Wet Textures" beginning on page 32).

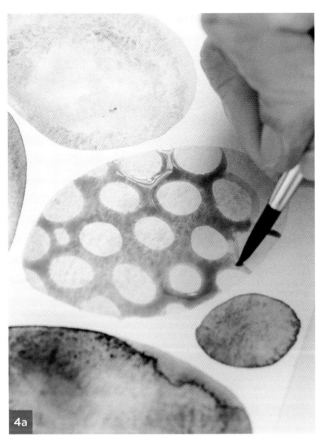

4a

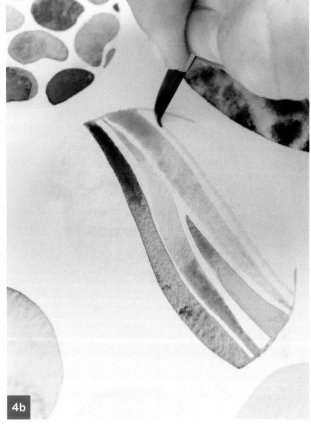

4b

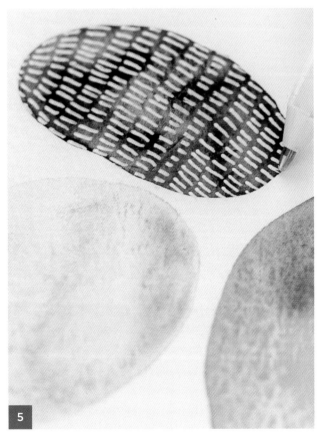

5

4. For these two stones, I'm adding layers of slightly darker paint but still maintaining a soft style. I'm tracing circles and painting the area around them to leave the negative space bubbles exposed (4a). I'm also painting irregular lines, similar to tiger stripes (4b).

5. Use any desired medium to create different textures. In this example, I'm tracing a pattern of small lines using a fine-tip white gel pen. See the top of the following page for more ideas.

(continued)

MINDFUL PAINTING

DRAWING SIMPLE TEXTURES

You can use colored pencils, gel pens, and metallic pens to draw many simple textures. I used white because it contrasts nicely with the blue paints.

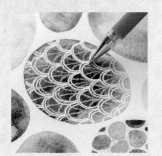
Scale patterns

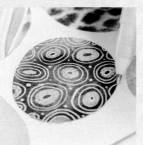
Concentric circles

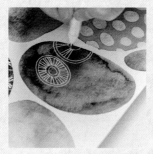
Sunburst shapes

Tiny ornaments

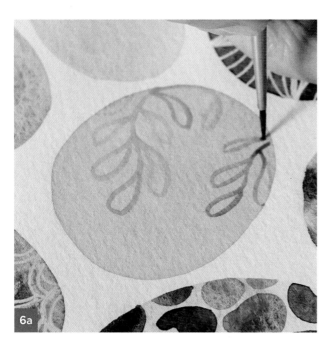
6a

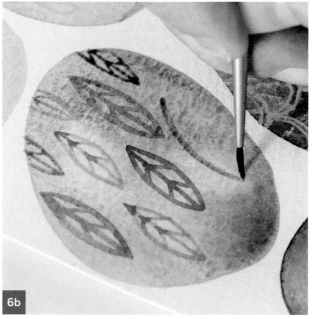
6b

6. You can also create detailed textures with fine lines by using a liner brush. These two examples (6a, 6b) are inspired by leaves.

7. Your artwork will be complete once you have added textures to all your stones.

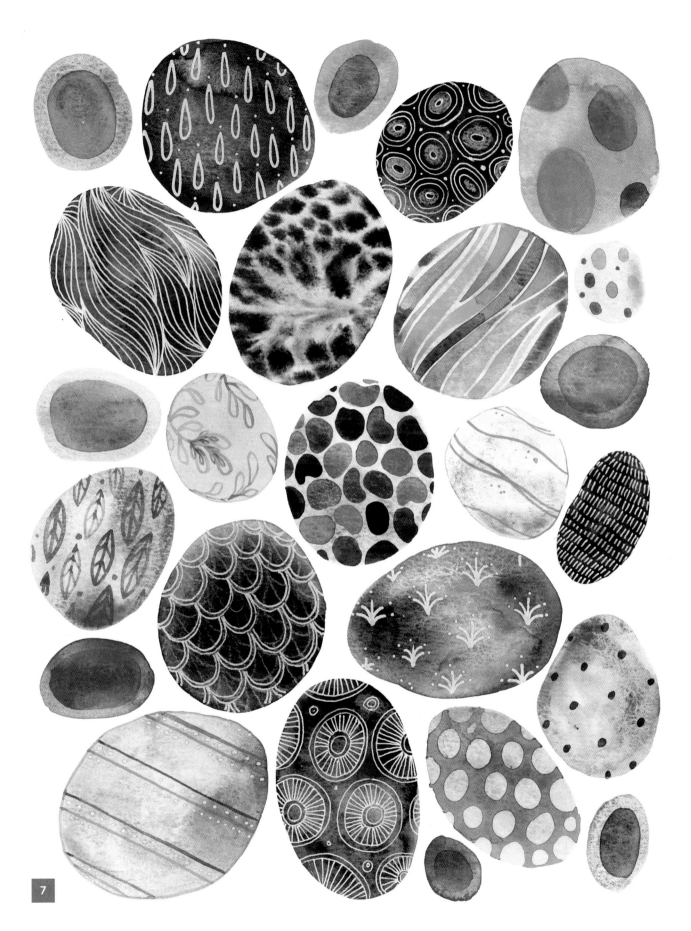

VARIATION: WARM TONES

Re-create the same exercise in different color palettes, and see the artwork transform into something completely different. Experimenting with color allows artists to alter the mood and environment of a painting.

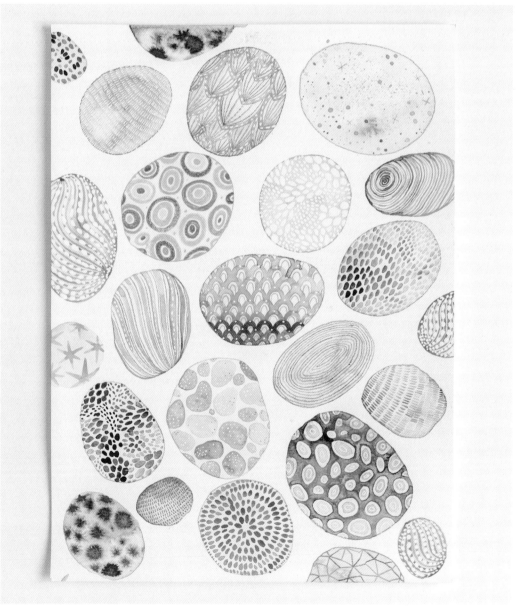

ABSTRACT STRIPES

Choose a cohesive color palette before you begin. I suggest picking two or three colors that you can mix together to create a variety of tones. I'm using potter's pink, gold ochre for brightness, and dark blue indigo for contrast. Layering these colors will produce interesting browns and earth tones.

I advise limiting your color palette for this style of painting. If you are using tubes (like I am in this demonstration), drop a bit of each color on a clean ceramic palette, mix, and let the magic of color happen there. You can use any color combination that pleases you. If you like bright and bold colors, a mix of magenta, turquoise, and lime green would be beautiful.

(continued)

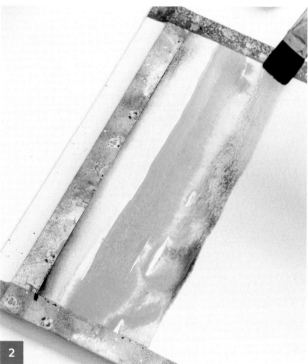

1. Use a large, preferably flat, brush that can hold a large amount of paint. A benefit to using flat brushes is that you can dip the brush into different colors on your palette and create interesting gradients with one single stroke. I used watered-down ochre as a base with a touch of indigo on the top corner. Paint a steady horizontal stroke from one side of the paper to the other.

2. Paint more stripes following the same idea. Use the colors you chose in your palette, and paint different stripes organically. The thick stripes should be quite close to each other. In fact, some stripes can make contact with the neighboring ones while still wet to achieve intentional bleeding.

3. Continue this process from top to bottom until you have filled the entire page. Let dry completely.

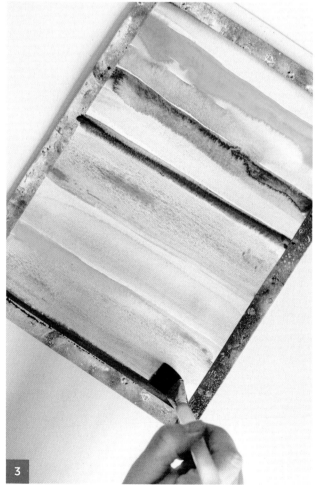

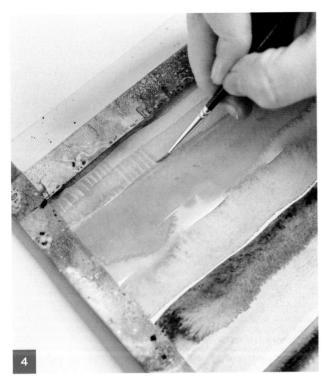

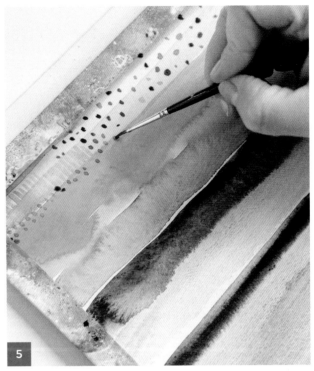

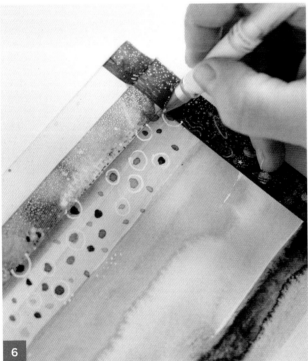

4. With a medium or small brush, paint a second layer of textures. Use the stripes and the natural effects of the watercolor to guide you.

5. Paint stripes, circles, dots, leaves, and anything that comes up naturally. Let yourself be immersed in this abstract work of art. If you need more ideas, refer to the wet-on-dry swatches for inspiration.

6. Use mixed-media tools, such as white gel pens, for details. This painting is a great way to apply the textures you practiced for mixed-media swatches on pages 42-53.

(continued)

MINDFUL PAINTING

7. Keep adding layered textures using watercolor, pens, and even colored pencils until you have reached the bottom of the page.

8. Go back and look over your design to see where there might be room for more details. I like to use a gold pen to unify the painting and for embellishment.

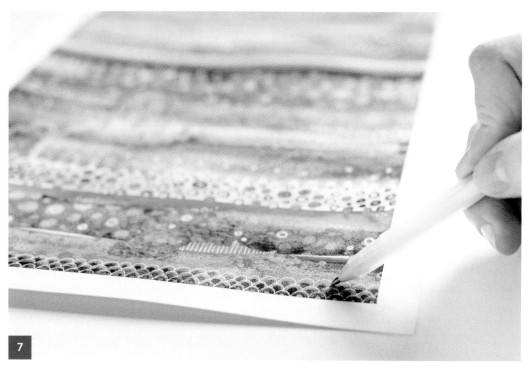

7

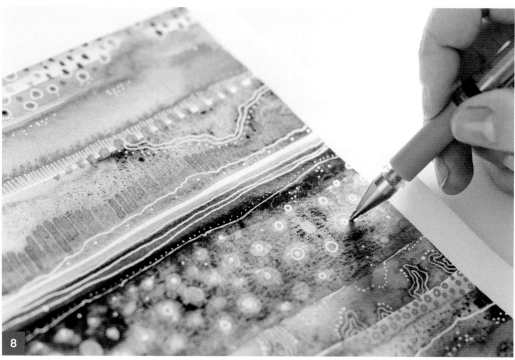

8

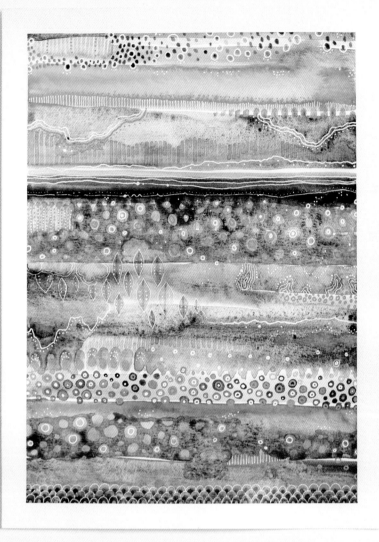

9

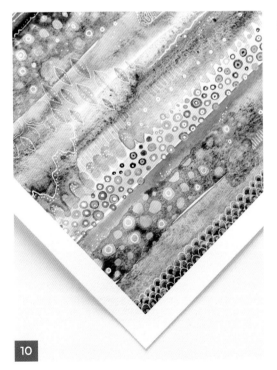

10

9. Lift the tape for the final reveal.

10. Here is a closer look at details and ideas on how to incorporate textures for a beautiful abstract painting.

SAND DOLLARS AND SEA URCHINS

I grew up close to the beach, and coastal art was something that I saw quite frequently in homes and vacation spots. There is something so calming about these underwater motifs, and this is the perfect way to repurpose circle paintings into something quite beautiful and interesting to look at.

1. Load up a large brush with watered-down paints to create a circle on an arbitrary area of the paper. Using the wet-on-wet technique, add a touch of another color into the wash.

2. While the paint is still wet, paint a circle right next to the first one using a different color. We are aiming for intentional bleeding; this means some of the color will spread into the neighboring shape.

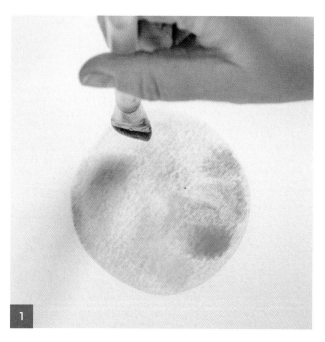

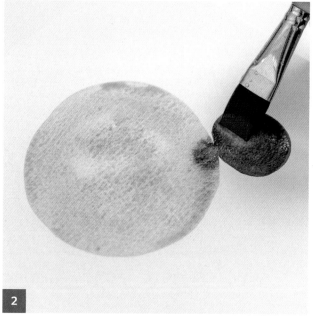

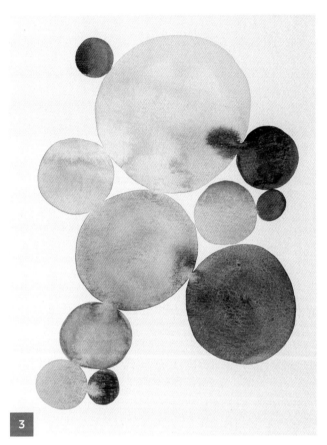

3

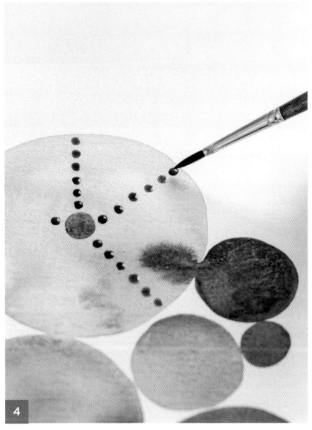

4

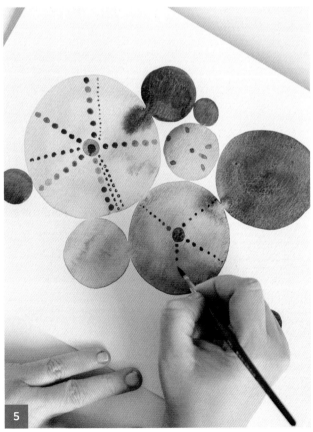

5

3. Keep painting circles until you have a composition similar to this example, and let dry.

4. Use a medium brush for the second layer. For each circle, paint a smaller circle inside, and even smaller circles radiating outward from the smaller center circle.

5. Use different colors from your palette for the rest of the circles.

(continued)

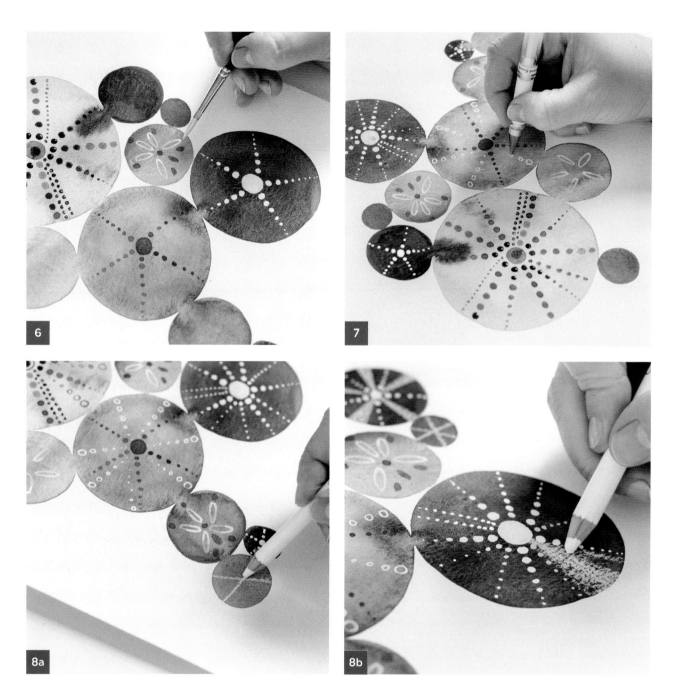

6. Some of the circles may also be decorated with small oval shapes for a sand dollar motif. At this point you can begin to integrate white ink as well.

7. Continue painting circles and dots using various pens and pencils.

8. For an interesting touch, use a white pencil or chalk pencil to fill out some areas in between (8a, 8b).

9. You have just completed a stunning coastal design! This painting is so simple yet brings so much joy.

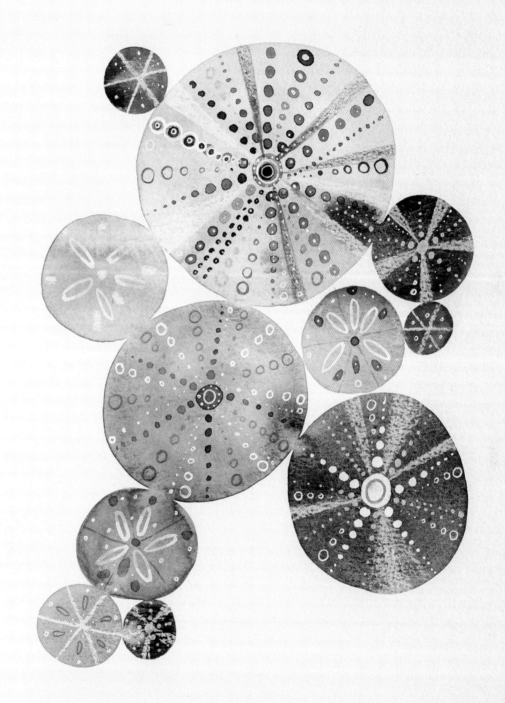

ZEN PEBBLES

Stone stacking is a peaceful way to arrange rocks by balancing them into natural sculptures. Here is a beautiful method of painting these calming structures.

1. Draw a stack of irregular circles using a pencil. The idea is to create a sense of balance among the different-shaped pebbles. I suggest using a muted color palette of gray and other neutrals for this project.

2. Use a white crayon to draw some simple lines over each pebble for an interesting effect. Paint the first layers of paint; the wax resists the watercolor paint to reveal this simple yet elegant texture. Use the wet-on-wet technique to add texture to each rock by dropping dabs of darker paint while the initial layers are still wet.

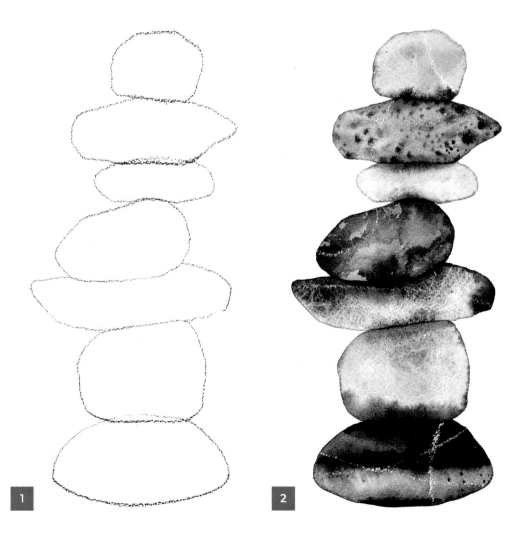

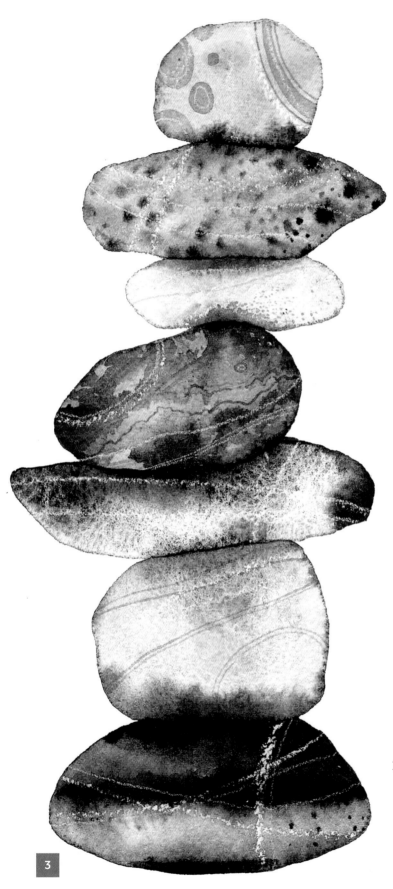

3

CREATIVE CHALLENGE

If you are close to nature, take an art field trip! Pack a watercolor sketchbook, and document textures found in rocks and pebbles. Our artwork is elevated when we slow down and take the time to observe fine details around us.

3. Once the paint has dried, use more watercolor paint and a white pencil to add details. For this activity, we are aiming for a more realistic approach, so simple dots and lines are appropriate.

MINDFUL PAINTING

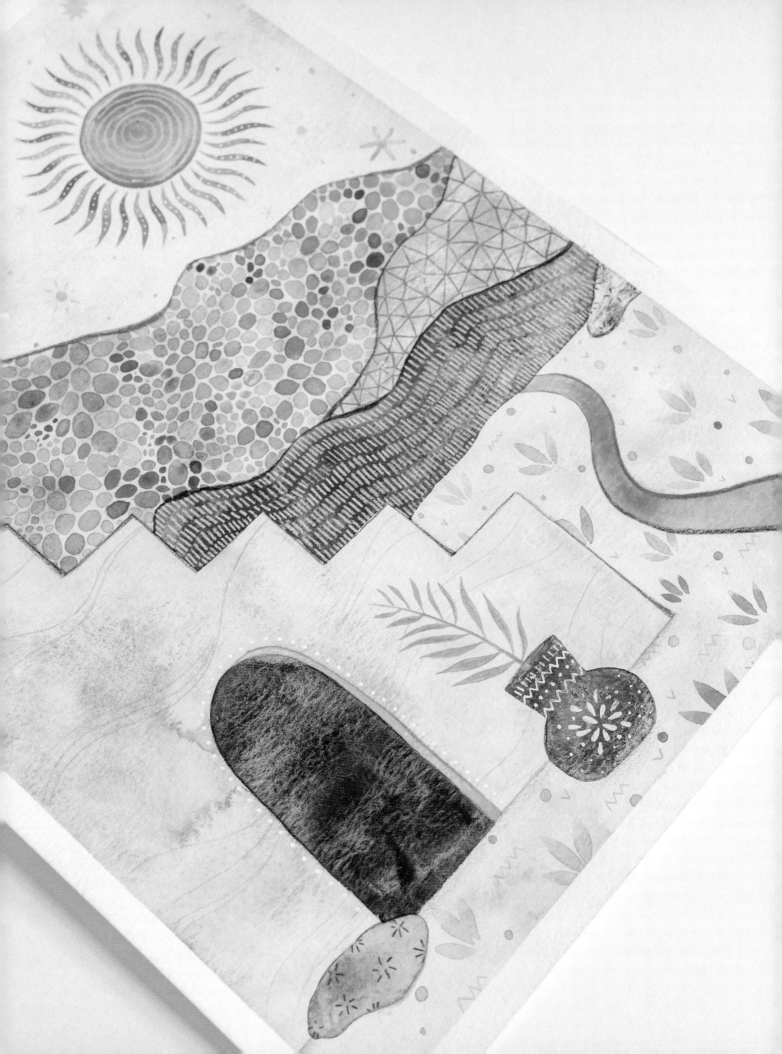

MYSTICAL LANDSCAPES AND SKYSCAPES

The use of textures is a wonderful tool for enhancing natural scenery. As mentioned in the introduction, this book plays with forms and figures in a way that is playful and endlessly fun to paint. This style does not necessarily focus on realistic drawings or strict drawing techniques; instead, I encourage you to use your imagination and dream up new environments inspired by the scenery around you or, in some cases, science fiction.

DREAMY GREEN MEADOW, TWO WAYS

Here are two different methods to paint a dreamy meadow with soft hills and mountains.

METHOD 1: WET-ON-WET WITH WHITE INK

1. Draw a simple mountain horizon (an irregular line across the page). This will separate your page into two parts, the sky and the greenery. Paint the sky using a simple blue gradient. Use the wet-on-wet technique for the green area. Use a variety of greens, and allow them to blend into each other.

2. Once the paint has dried, you will be able to observe different sections of the green tones. These areas will not have harsh edges but will instead blend into each other organically. Follow the natural flow of these areas to add different styles of textures using a second layer of watercolor paint.

 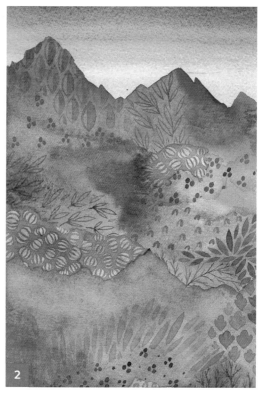

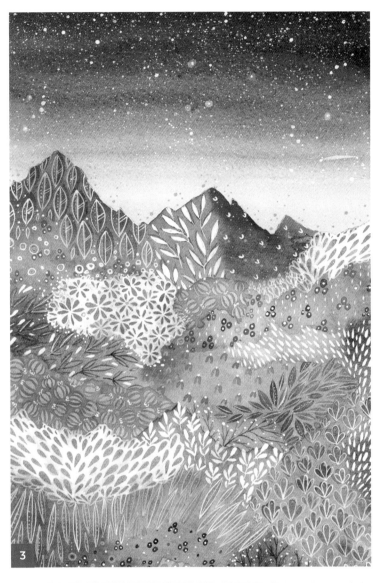

3. Allow the second layer with watercolor textures to dry completely, and add a final layer of detailed textures using white ink.

(continued)

WHITE INK

White ink interacts beautifully over watercolor paint. It is opaque enough to cover a painted area but can also be transparent when diluted with water, which can react with the layer of watercolor below. Alternatives to white ink are white gouache or acrylic; although their textures are different, they still provide great coverage. These are my personal favorite high-quality white inks:

- Copic Opaque White

- Kuretake White Ink

- Dr. Ph. Martin's Bleedproof White

METHOD 2: SECTIONAL WATERCOLOR AREAS WITH MIXED-MEDIA DETAILS

1. Draw a series of irregular horizontal lines and shapes across the page. You can use the template on page 125 for reference.

2. Fill out these different areas using various tones of greens. It's important to allow each area to dry completely before painting the one next to it to avoid bleeding. Paint the large area with rocks using turquoise or blue for the appearance of a river.

3. Continue painting each section, always making sure the neighboring area has dried completely. Use deep purples and browns on the rocks for contrast.

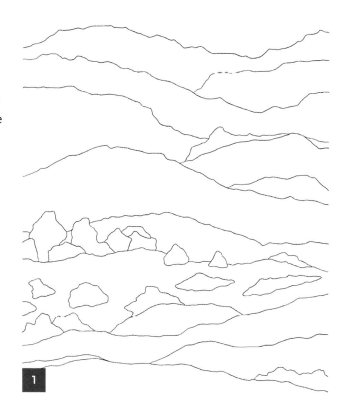

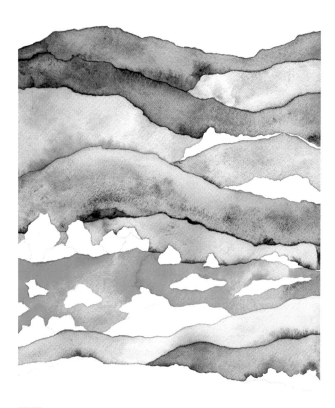

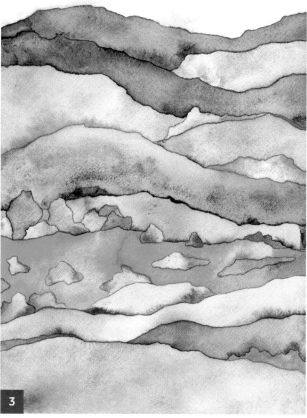

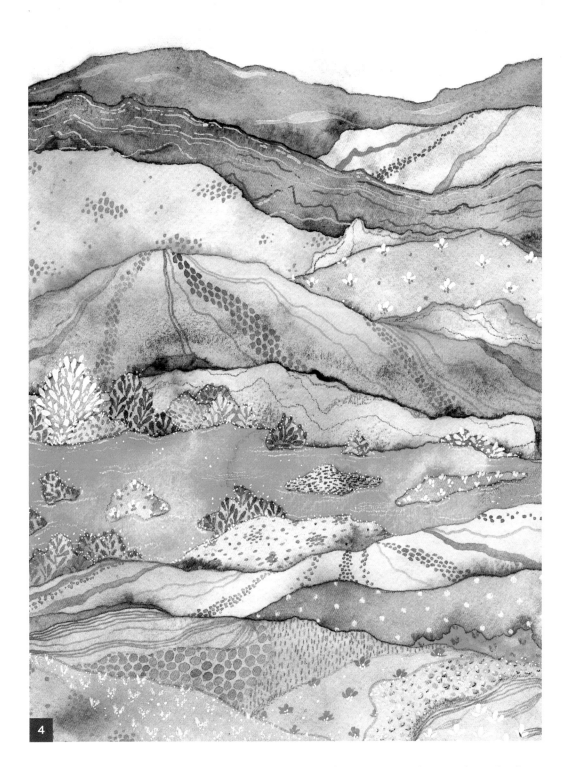

4

4. Add different styles of patterns and textures on each green area using a variety of paint, white ink, and colored pencils.

INTERGALACTIC PLANETS

I absolutely love painting *fantasyscapes*. There are no limitations, and you can let your imagination run freely. Science-fiction movie posters from the 1970s provide endless inspiration when painting far-out outer-space worlds like these.

1. Use a pencil to draw the outline of the hills and planets. For a larger reference, refer to the template on page 126.

2. Choose a color palette before you begin painting. Now that you have plenty of experience with textures, choose a few ideas from your swatches. This is a great way to visualize your work and make artistic decisions before beginning the large painting.

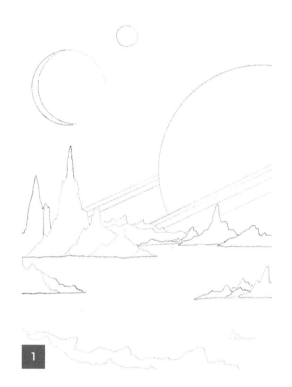

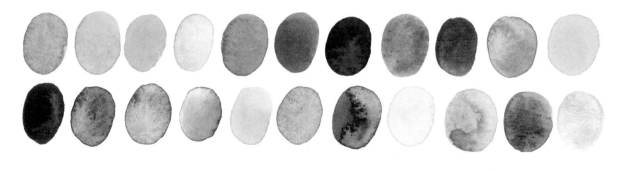

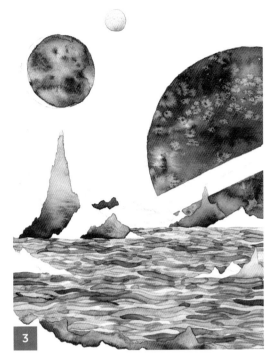

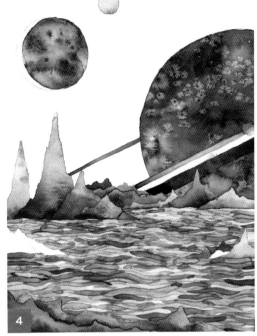

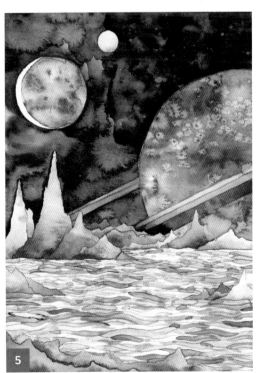

3. Begin by filling in the different sections. When painting with watercolors, it's important to think strategically instead of waiting for paint to dry all day. While painting the waves, I painted a few brushstrokes all around my water area, and while I waited for these to dry, I began painting the planets. Once the initial waves dried, I went in and painted more waves to prevent bleeding between the different blue brushstrokes. The large planet is a classic watercolor texture where you create a wet-on-wet wash and sprinkle a small amount of salt over the wet paint. Once the paint has dried completely, brush off the salt.

4. Continue painting the different sections of the drawing. Always make sure the neighboring areas have dried.

5. Once the planets and hills have dried, paint the sky using concentrated indigo watercolor for a deep night-sky effect.

(continued)

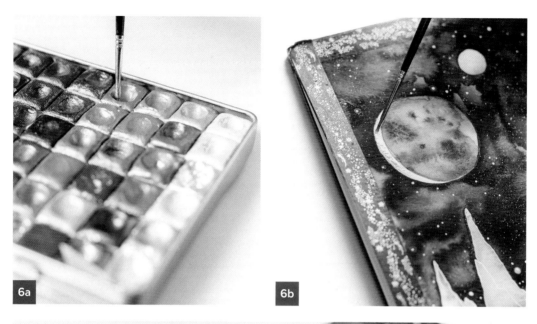

6a

6b

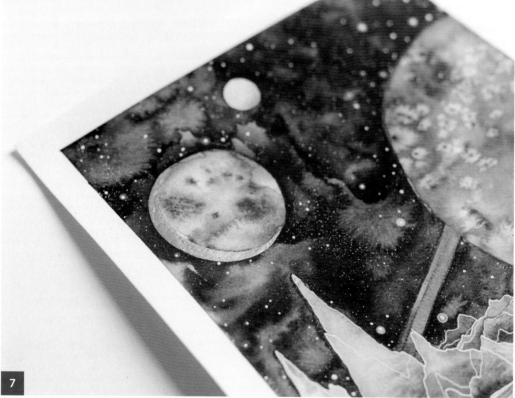

7

6. Use gold watercolor to paint the moon (6a, 6b). Alternatives to gold watercolors are metallic inks, gold leaf, or gold markers and pens.

7. Complete the painting with white ink for final details and textures. Splatter ink for the stars, and use a fine liner brush to decorate the mountains and hills.

8. If using tape, remove the border for the final reveal!

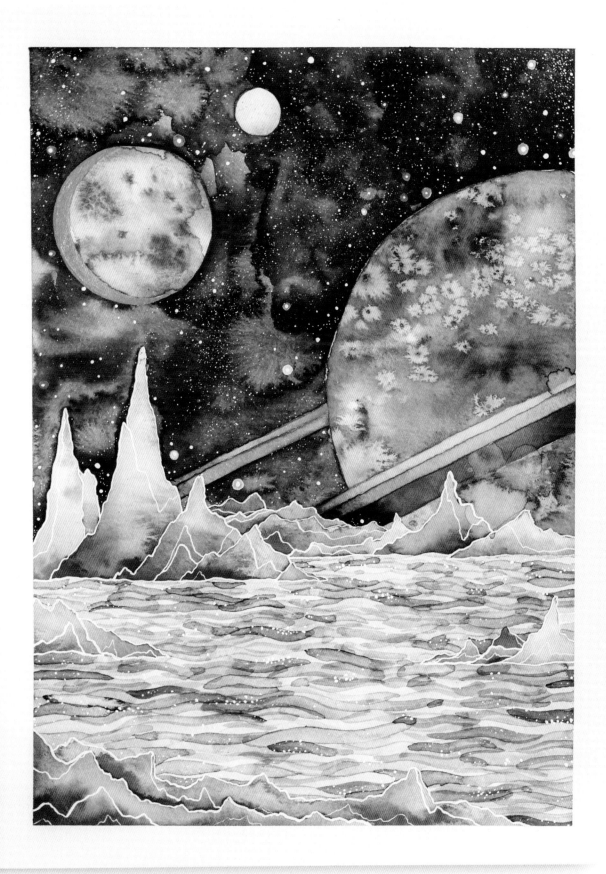

TULIP FIELD

This dreamy painting will take you on an imaginary field trip to the Netherlands. Simple lines and color blocking are the foundation of this landscape.

1. This design works best when following a technical drawing method (1a). Trace a horizon line (A) and a vanishing point (B), and then trace lines radiating outward (C) with a ruler (1b). See page 127 for the template.

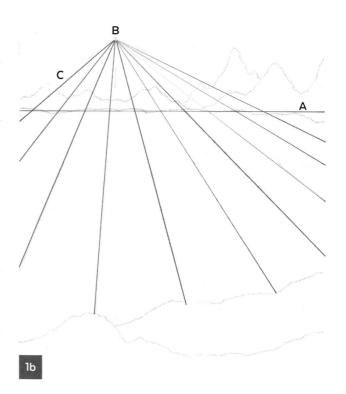

1a

1b

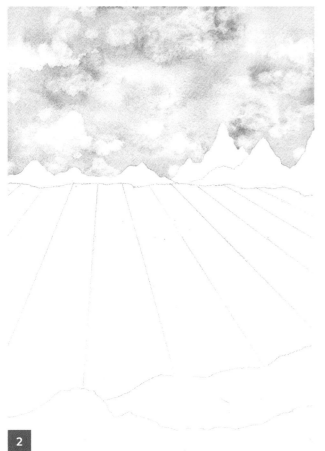

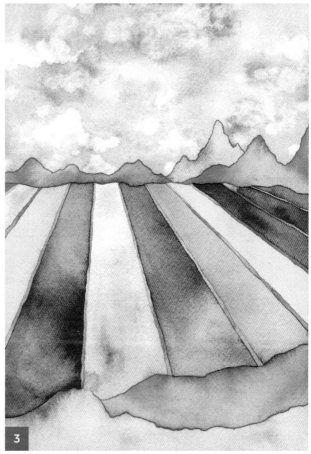

2. Paint a flat wash with blue paint for the sky, and lift up cloud shapes using tissues.

3. Fill in all the areas of the drawing with different colors. Choose bright tones for the tulips. These layers should be light to medium tones, so use enough water to mix each color.

(continued)

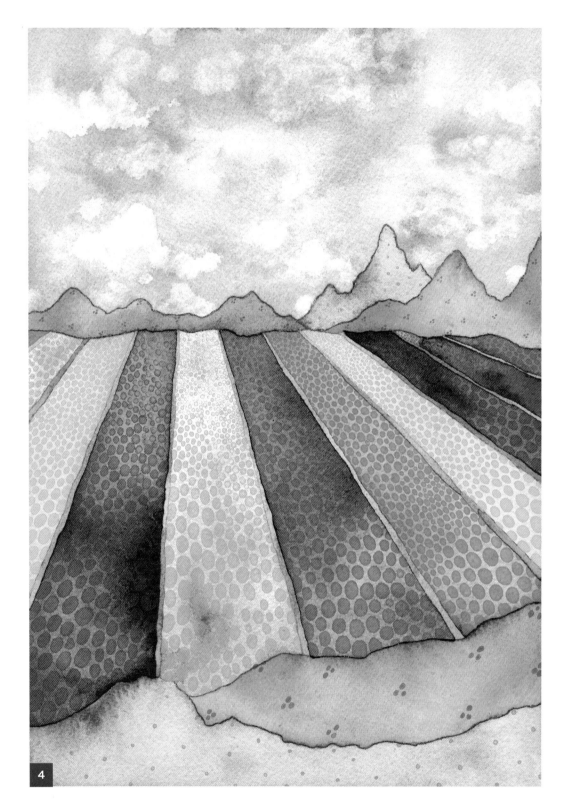

4

4. Once all the layers of paint have dried, paint details using dots. The dots will vary in size, direction, and spacing. This variety will provide interesting movement and perspective in the painting.

ADDITIONAL IDEAS AND FURTHER INSPIRATION

Textures can enhance absolutely any subject matter you enjoy painting. Here are a few more examples of different ways to try watercolor textures and patterns. The possibilities are truly endless!

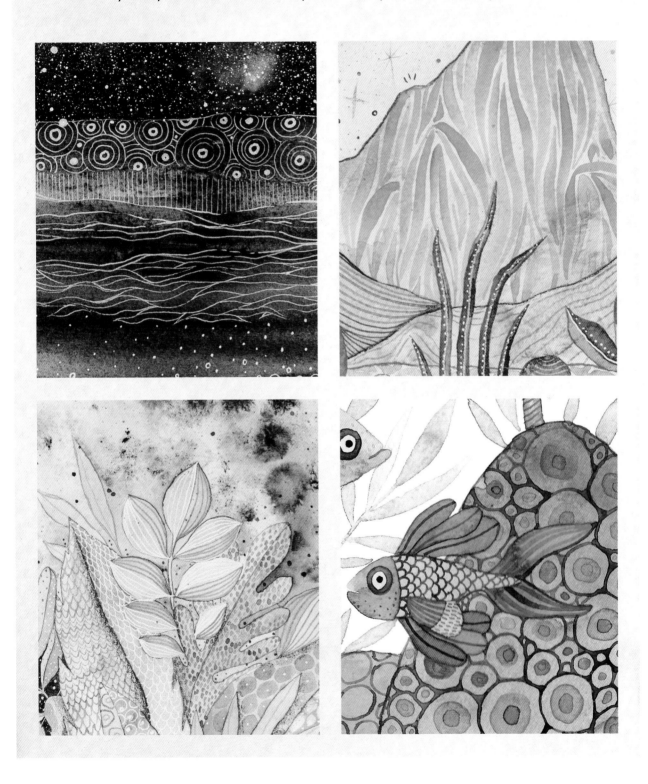

MIDNIGHT WONDER

This painting is an alternate way to apply the abstract stripes method demonstrated on page 89. The drawing is extremely simple, consisting of a horizon line where the sky meets the ocean and a circle for the moon or sun, depending on your color palette. The ocean is created by painting thick stripes of different blues and allowing the colors to blend into each other while wet.

1. I used a silver Uni-Ball pen for the detailed textures over the ocean.

2. A splatter of white ink for the starry night and moon can be created using vibrant wet-on-wet splatter (Dr. Ph. Martin's Radiant Juniper Green is a wonderful vibrant color for this effect) or sprinkling Brusho crystals (or powdered pigment) on to a wet surface.

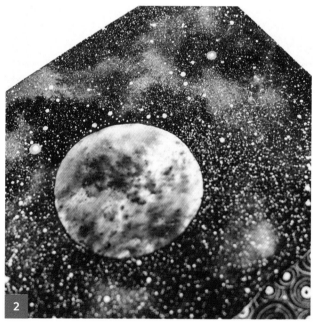

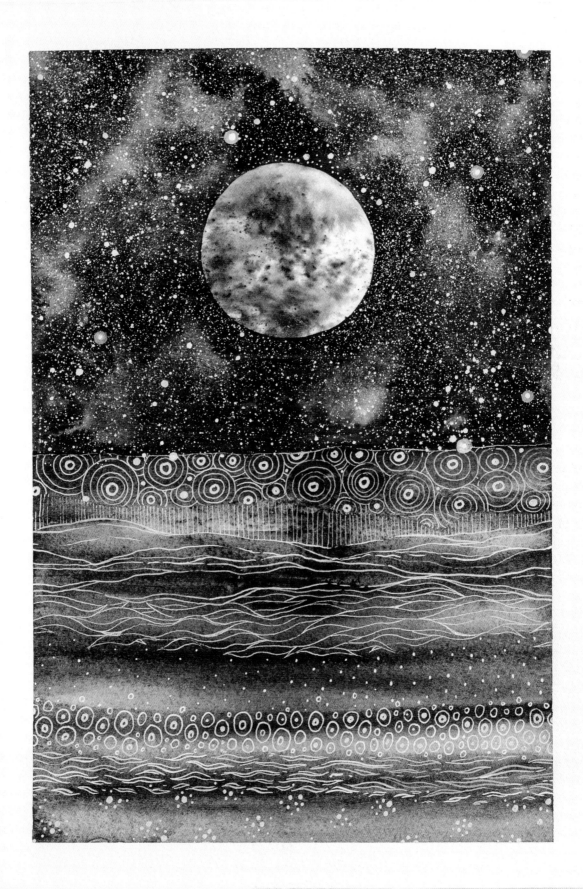

DESERT DUNES

One summer I was teaching at a watercolor retreat in Italy, and my students and I stumbled into a small art supply shop on a cobblestone street. In the corner of the shop, I found this beautiful round watercolor paper pad, and it had to come home with me! If you happen to come across round watercolor paper, I suggest you give it a try. The format is delightful and instantly frames any painting in a unique way. I drew a simple desert scene with some vegetation using the following warm colors: yellow ochre by Winsor & Newton, potter's pink by Daniel Smith, and pozzuoli earth by Schmincke. The layering method is wet-on-dry, which is described on pages 24–31.

See below for some closer looks at the textures.

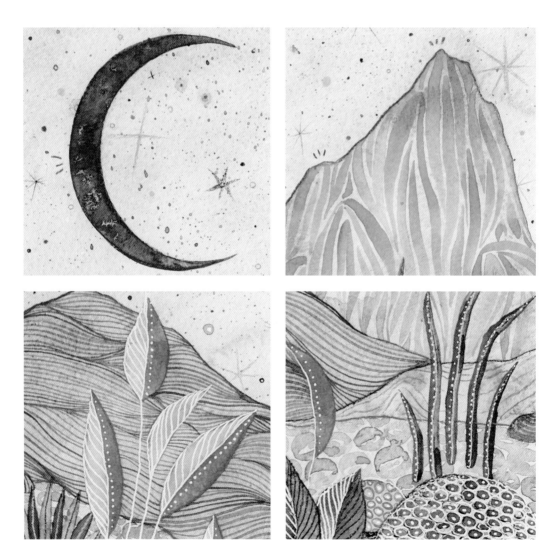

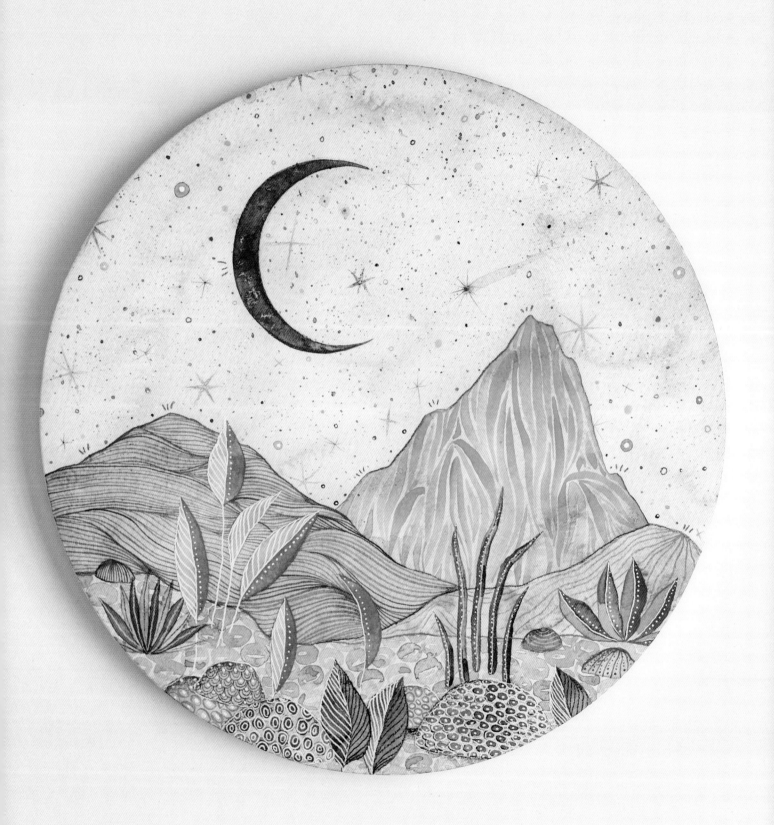

PLANTS IN THE MOONLIGHT

I love the idea of plants coming to life at night. This composition makes me feel like the leaves are dancing under the moonlight, soaking up all the full-moon energy. You can find a template to a drawing in this style on page 128.

The moon is painted using the wet-on-wet method featuring drops of black ink and blue watercolor, while the sky is created with a wash of black watercolor paint and white ink splatter. The moonrays are traced on with a white pencil and ruler. The textures on the plants are wet-on-dry method using watercolor layering and white ink over watercolor.

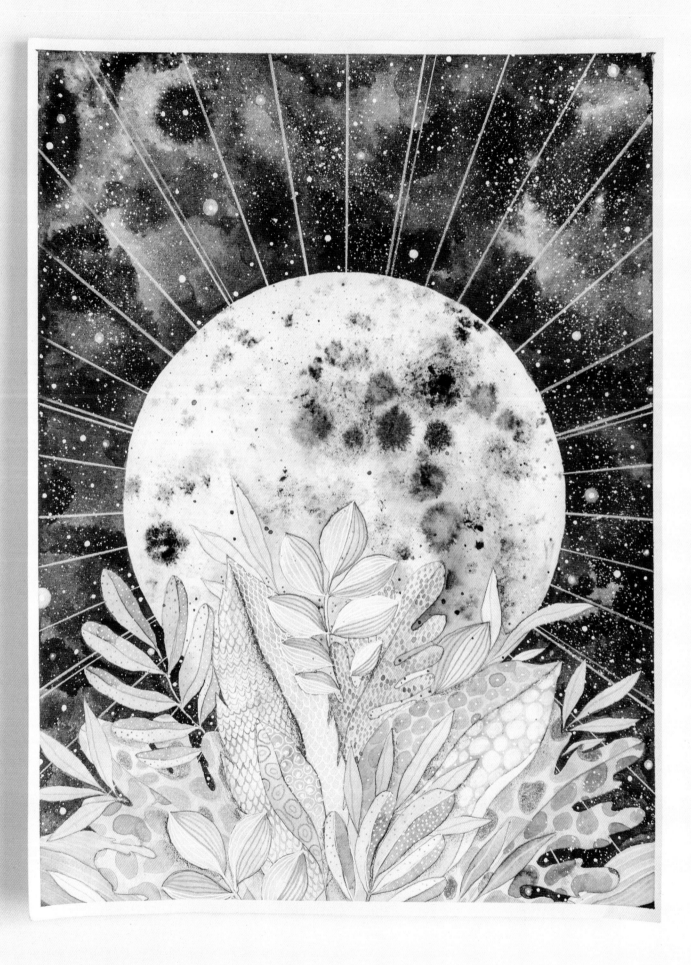

CORAL REEF

Although not technically a landscape, this natural scene is a wonderful subject for the techniques demonstrated in this book. Corals follow the formula of simple outlined shapes that are beautifully enhanced with textures. There are hundreds of organic patterns to be discovered by observing these magical underwater scenes, such as the two inspired textures on pages 62 and 68. Refer to page 129 for an outlined template drawing of this painting, and create an underwater world of your own!

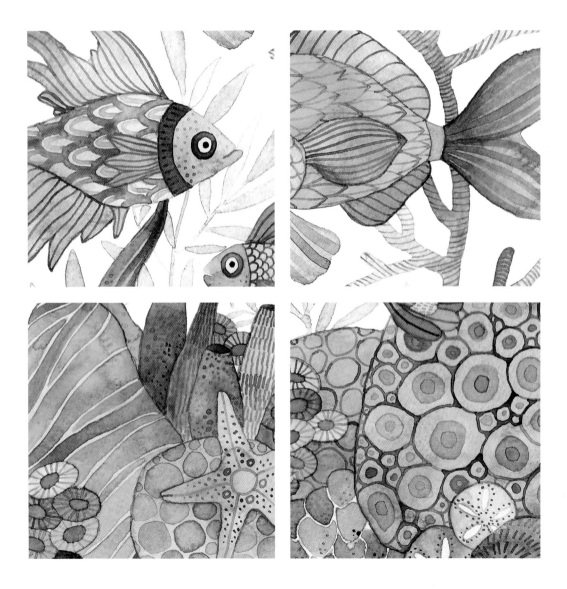

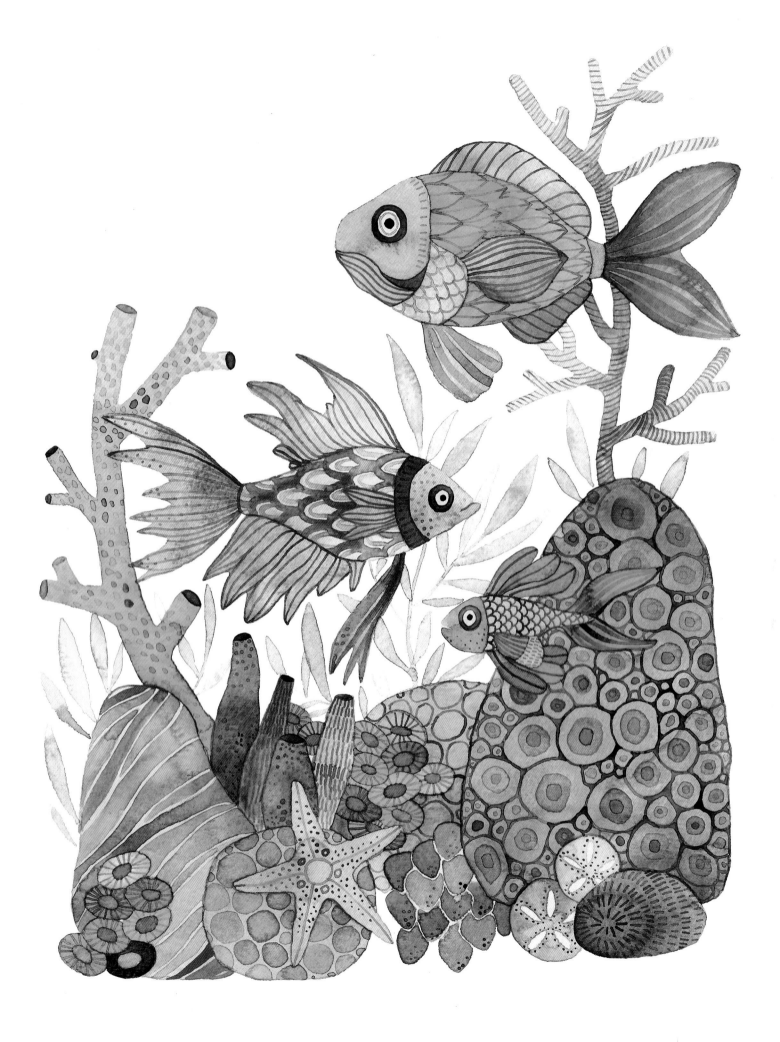

THE POWER OF COLOR

As mentioned in the Introduction, there is a list of main elements that compose a piece of art. Two of those elements are texture and color. Although this book focuses on texture, I wanted to show an example of the same drawing using two different color palettes and how this impacts the general mood of a painting. A color palette can indicate time of day, weather, geographical location, temperature, and sentiment. Both paintings have a variety of textures but are very different from each other.

See page 130 for the template. Experiment!

CREATIVE CHALLENGE

Replicate the same drawing on two different sheets of watercolor paper, and create a color palette for each of these drawings. A great way to do this is to think of two different concepts. For example, "Serene Winter Day" could be a palette of crisp blues and cool violets and silver details. For "Earthy Terrain," I would envision reddish browns, burnt oranges, and golden ochres.

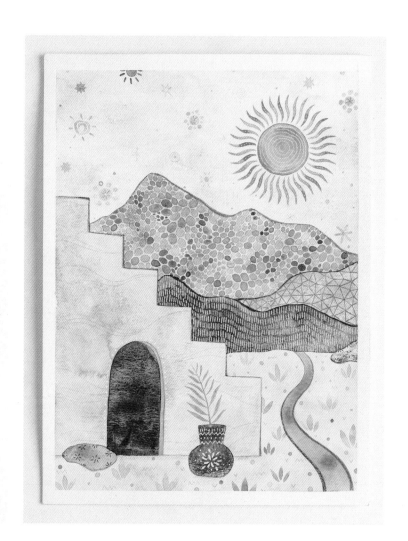

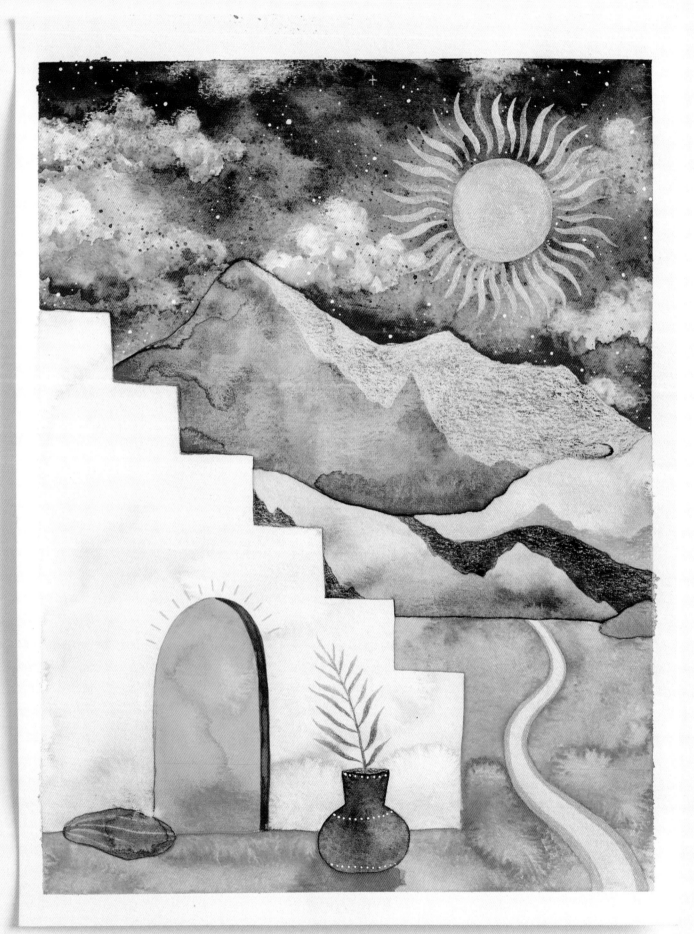

TEMPLATES

Enjoy the following outline drawings as guides to create beautiful watercolor paintings by using textures and patterns with the techniques you have learned throughout this book.

HOW TO TRANSFER YOUR TEMPLATES

Here are four different ways to transfer outline templates on to watercolor paper.

1. **Transfer**: Print out the template and scribble all over the blank side of the paper using a soft pencil with darker graphite, such as a B or HB. Flip the paper over and place it on top of your watercolor paper. Secure with tape on the four corners and use a ballpoint pen to trace over the outline drawing. Lift up the sheet of watercolor paper, and you will have a transferred drawing directly on your paper. This method is the most effective, especially when using heavy watercolor paper. Scan the QR code on this page to access the printable templates.

2. **Sunny window**: Print the template, tape it to a sunny window, then center and tape your watercolor paper over the outline drawing. It's important to secure your paper in place for a precise transfer. Use a pencil to trace over the lines until you have completed the design.

3. **Light box**: Also known as a light pad or light board, this device is an illuminated panel you can place paper over for tracing or to observe details more effectively. Use the same method you would use when holding the paper up to the window but use a light box instead. There are many affordable options online, mostly USB-powered and with LED lighting. This method is comfortable and works great as long as your paper is not extremely thick or heavy so the light can actually pass through.

4. **Use your tablet as a light box**: Lock your tablet so the image does not move and place the watercolor paper directly over the illuminated drawing. This method has some restrictions: The size of your tablet may be smaller than the desired size of the painting, and the screen's brightness is not always luminous enough to make it through to thick watercolor paper. It's worth it to give it a try! Under the right circumstances, this can be quite practical.

DREAMY GREEN MEADOW

See pages 102–105.

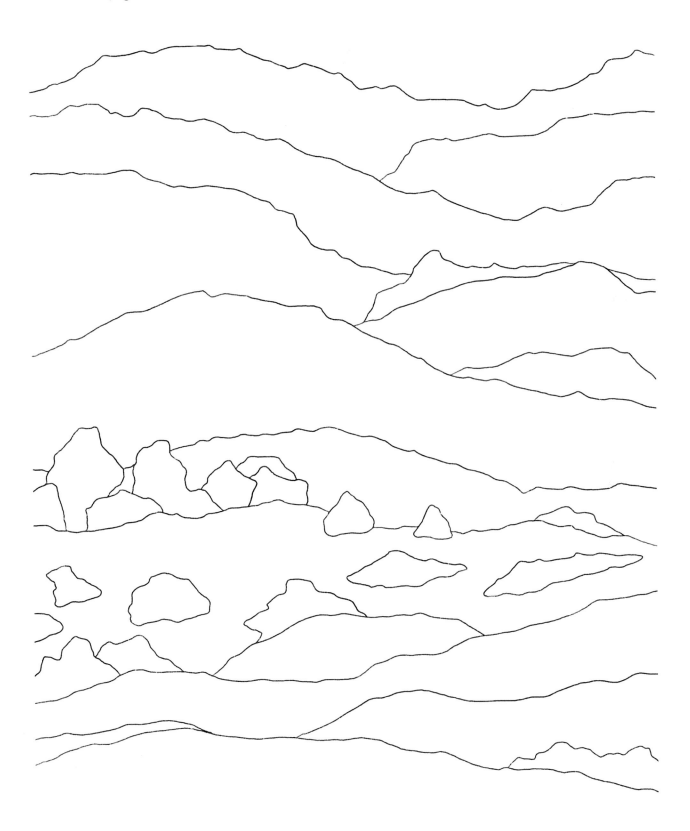

INTERGALACTIC PLANETS

See pages 106–109.

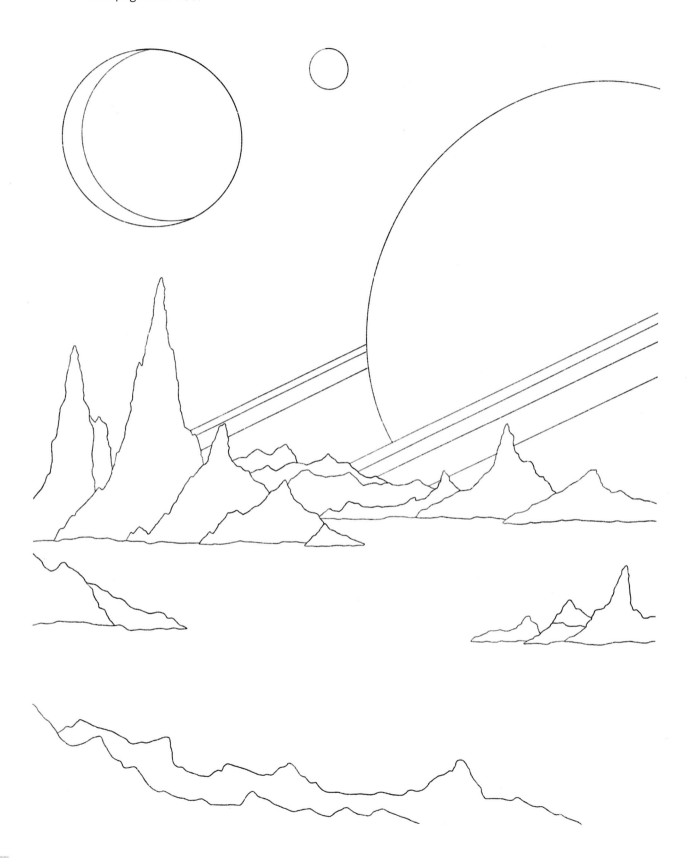

TULIP FIELD

See pages 110–112.

PLANTS IN THE MOONLIGHT

See pages 118–121.

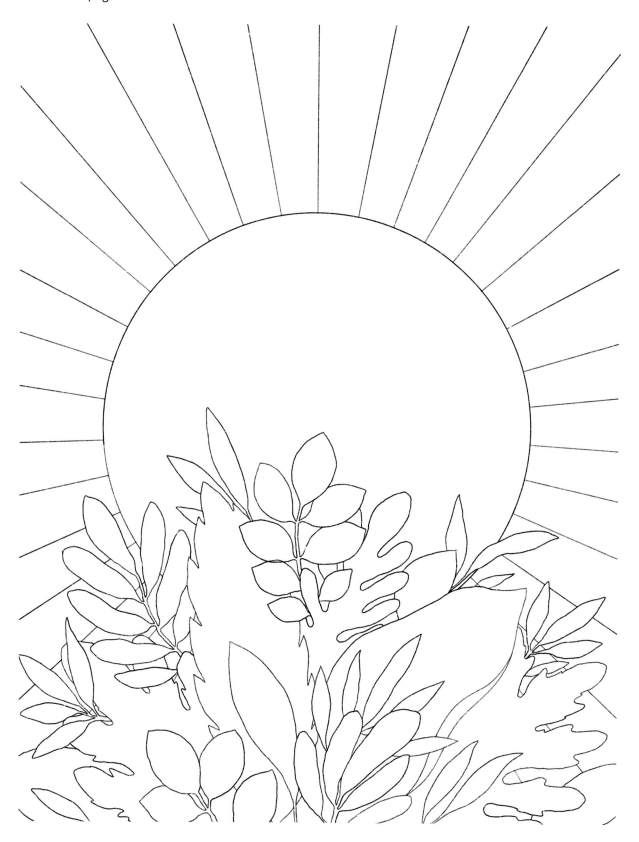

CORAL REEF

See pages 120–121.

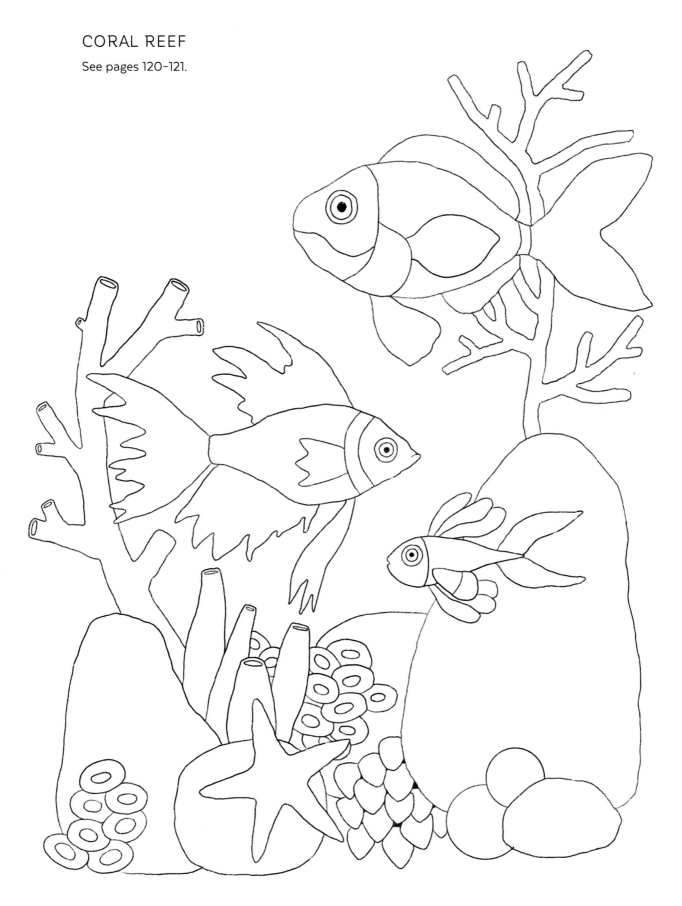

THE POWER OF COLOR: ADOBE DWELLING IN THE DESERT

See pages 122–123.

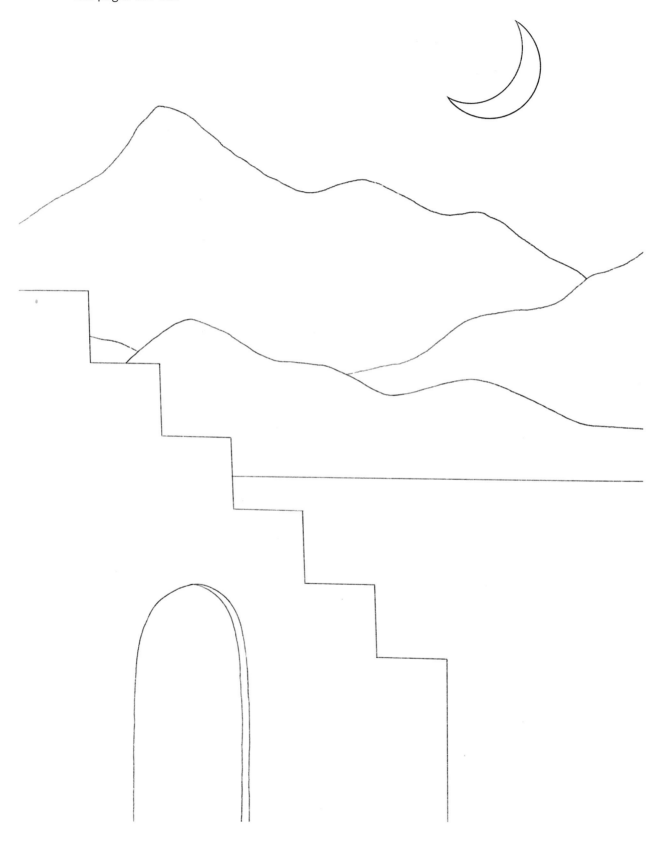

BONUS TEMPLATES

The textures and patterns demonstrated in this book can be applied to an infinite number of drawings! As an artist, the subject matter is your choice. Use textures to add an additional layer of interest to your personal artwork. Here is a collection of bonus templates featuring different designs that I find extremely fun to paint. Take the activities in this book beyond the demonstrations and let your color palettes and imagination lead the way!

MOON PHASES WITH MOUNTAINS

COASTAL HILLS

SAGUARO ROAD

RESOURCES

For further watercolor instruction, please refer to my online courses:

- www.skillshare.com/r/user/anavictoriana

- www.domestika.org/anavictoriana

If you would like to continue your artistic journey and attend in-person workshops and retreats, please visit: www.anavictoria.com/learn.

To learn more about the J. Paul Getty Museum (page 10), visit: www.getty.edu/museum.

RECOMMENDED ART SUPPLIES

Canson
en.canson.com

Caran D'Ache
www.carandache.com

Copic
www.copic.jp/en

Daniel Smith
www.danielsmith.com

Derwent
www.derwentart.us

Dr. Ph. Martin's
www.docmartins.com

Gelly Roll Classic Gel Pen
www.sakuraofamerica.com

Holbein
www.holbeinartistmaterials.com

Hydracolour
Metallic watercolor paints
www.etsy.com/shop/HydraColour

Kremer Pigmente
shop.kremerpigments.com/us

Legion Paper
www.legionpaper.com/stonehenge

Pilot Markers
www.pilotpen.com

Princeton
www.princetonbrush.com

Prismacolor
www.prismacolor.com

Sennelier
www.sennelier-colors.com

Uni-Ball
uniballco.com

Winsor & Newton
www.winsornewton.com

ACKNOWLEDGMENTS

I am incredibly grateful to each and every one of my students and readers. Thanks to you and your constant enthusiasm, we are on book number five! I can hardly believe it. My first book, *Creative Watercolor*, was published back in 2018, and since then you have been my main motivation to continue sharing my love for watercolor and the creative practice. Please know that art-making will always be available to you. You can always come back to it, no matter how long it has been since you last held a paintbrush. This practice is beneficial to your holistic well-being and the world around you. There is nothing more beautiful than expressing what is in your heart through your hands.

As always, I would like to thank the incredible team at Quarto for believing in my art for all these years and the incredible team of editors, spellcheckers, designers, publishers, printers, and the wonderful marketing team that makes sure this book reaches as many curious creators as possible. I am honored to be a part of this collaboration. Writing books has allowed me to share my love for art with more people from around the world than I ever could have imagined!

To my family and friends: I have felt nothing but support from you my entire life. Thank you.

ABOUT THE AUTHOR

Ana Victoria Calderón is a Mexican American watercolor artist, author, and teacher based in Mexico. Her education is in graphic design and fine arts. In 2011, she began working as a full-time artist, and since then has published five books translated into multiple languages, including *Creative Watercolor* and *Color Harmony for Artists*, collaborated with multiple brands around the world, and licensed her art to companies that print premium stationery in the United States and Europe.

Ana is passionate about creative education, and she has had the pleasure of teaching around half a million students! She believes that authenticity is the path to freedom as an artist, which is something she tries to bring out in all her students.

Her artwork features elements in nature, florals, sacred geometry, cosmic themes, mystical landscapes, and fantasy. See more of Ana's work on Instagram (@anavictoriana), YouTube (Ana Victoria Calderon), and Facebook (Ana Victoria Calderon Illustration).

INDEX